C000214479

CENTRAL
SWANSEA
THROUGH TIME
David Gwynn

AMBERLEY PUBLISHING

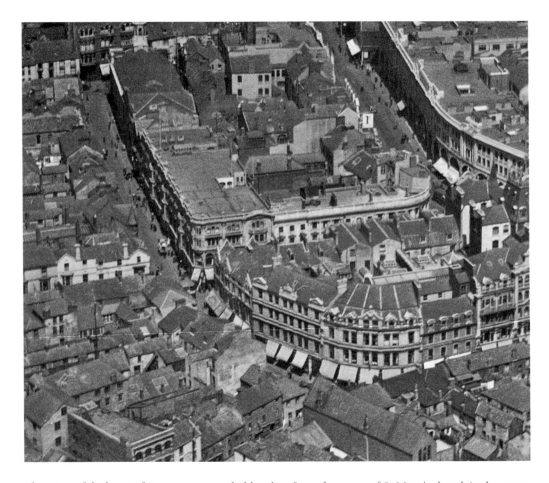

This view of the heart of Swansea was probably taken from the tower of St Mary's church in the 1920s. It shows the area just to the west of Ben Evans Department Store, with Goat Street running from the top down to the shops with the awnings pulled out. In this book, I will be concentrating on the centre of the city and its immediate environs. The suburbs will be the subject of a future publication. (*The Alan Jones Collection*)

First published 2013

Amberley Publishing
The Hill, Stroud
Gloucestershire, GL5 4EP

www.amberley-books.com

Copyright © David Gwynn, 2013

The right of David Gwynn to be identified as the Author of this work has been asserted in accordance with the Copyrights, Designs and Patents Act 1988.

ISBN 978 1 84868 302 0

All rights reserved. No part of this book may be reprinted or reproduced or utilised in any form or by any electronic, mechanical or other means, now known or hereafter invented, including photocopying and recording, or in any information storage or retrieval system, without the permission in writing from the Publishers.

British Library Cataloguing in Publication Data.
A catalogue record for this book is available from the British Library.

Typeset in 9.5pt on 12pt Celeste.
Typesetting by Amberley Publishing.
Printed in the UK.

Introduction

Swansea, Dylan Thomas' 'lovely, ugly, town' and self-styled 'city by the sea', has had a long and varied history. Its actual origins are lost in the mists of time and are the subject of some debate. It is known that the Romans settled in the area, proven by the existence of the remains of a villa at Oystermouth. It is possible that a ferry crossing somewhere along the lower reaches of the Tawe also had a few buildings to provide food and shelter for travellers. The most enduring legend concerns King Sweyn Forkbeard, a Viking ruler who was known to have been in the Bristol Channel area and may have established a encampment on an islet at the mouth of the River Tawe – hence the name Sweyn's Ey. The city's name gradually evolved until settling at Swansea in the early nineteenth century. In Welsh, the city is known as Abertawe, meaning 'mouth of the Tawe'.

After the Norman invasion of South Wales at the end of the eleventh century, a castle was built on the west bank of a now strategically important river. A network of streets developed around the castle which formed the heart of the little town. Today, this pattern of streets survives mostly intact. Throughout its early history, the town and castle were attacked and destroyed by the Welsh resistance. The last effective uprising led by Owain Glyndwr in the early fifteenth century saw the castle captured.

As Wales became a more peaceful place, the town began to thrive. The population had remained under 2,000 from the mid-1600s to the mid-1700s, but by 1800 had grown to over 10,000. The reason for this was that the first stirrings of the Industrial Revolution were being felt in the Swansea area. The first copper works opened in the rural area to the north of Swansea, at Landore, around 1717. In 1764 the Cambrian Pottery opened on a derelict site near the present railway station. There were coal mines already operating in the area, supplying fuel to these early works. Gradually, more copper works opened, together with

tinplate, lead, zinc and arsenic. By the 1830s, Swansea was recognised as the most important copper-smelting centre in the world. It acquired the nickname 'Copperopolis', and from 1857 had its own Metal Exchange, which forty years later was given Royal approval as the Royal Jubilee Metal Exchange. As new sources of ore were developed in South America, so the famous Copper Ore Barques of Swansea carried the ore from there to Swansea.

While the metallurgical industries were being born in the Swansea Valley, Swansea's other reputation was developing on the western edges of the town. In the eighteenth century Swansea was known as a spa resort, where genteel folk were able to take the waters, indulge in sea bathing, and relax at the Assembly Rooms. Georgian Swansea can still be traced around Cambrian Place and the Dylan Thomas Centre. Beau Nash, a contemporary of Beau Brumell, was a well-known dandy who frequented not just Swansea, but also Bath and London.

The arrival of the railways, though, established Swansea as a leading industrial centre. Any plans to develop the seafront were hampered by the arrival of the Llanelly Railway in 1866, running their main line into Swansea Victoria station along the shore from Blackpill, alongside the already established Swansea and Mumbles Railway. What remained of the genteel Georgian Swansea was soon overwhelmed by the bustling, thriving town that had come to dominate the world's metallurgical industries.

The town suffered its worst blow during the Second World War, when, in February 1941, it suffered three nights of intensive bombing by the Luftwaffe. The centre of the city was largely destroyed, with many landmark buildings disappearing forever. From the rubble, a new town centre grew, with wider streets and new buildings. Since the war, the town has strived to recover, not just from the bombs, but also from the decline and globalisation of the metallurgical industries on which it depended.

In 1969, as part of the celebrations surrounding the Investiture of the Prince of Wales, Swansea was granted city status. The Lower Swansea Valley Project led in the 1970s, '80s and '90s to the redevelopment of the derelict industrial sites at Landore, Hafod and Llansamlet, creating the Swansea Enterprise Park and Morfa Retail Park. The many changes to the commercial heart of the city are the focus of this book.

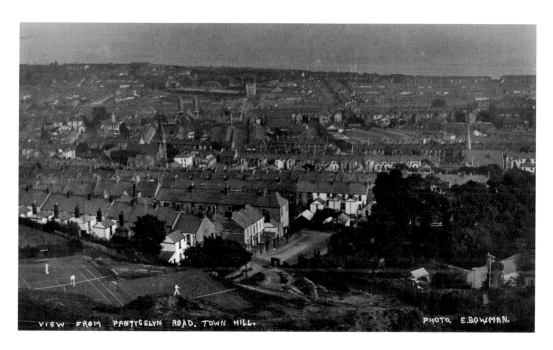

View from Pantycelyn Road, Townhill, 1927
This view shows how Swansea was confined for much of its history within a coastal strip either side of the mouth of the River Tawe. The view today is dominated by the Meridian Tower, Wales' tallest building, built at the western end of the Marina.

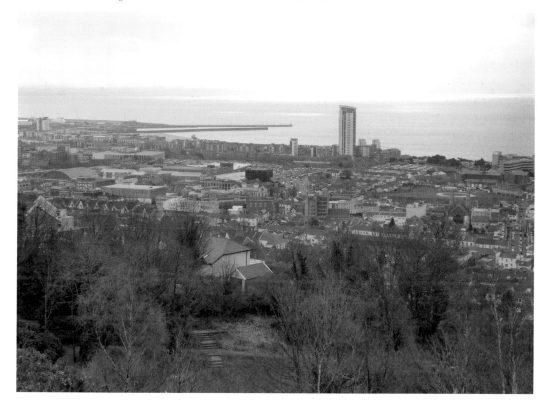

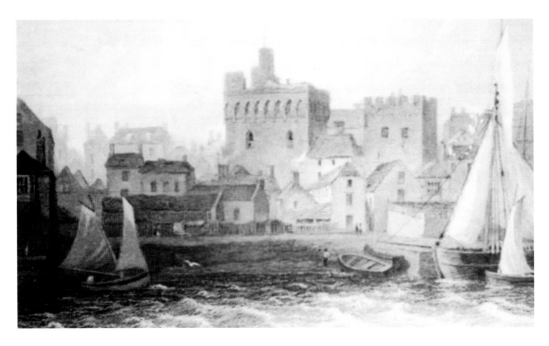

Swansea Castle, Early Eighteenth Century

The original castle at Swansea was built by Henry de Newburgh between 1099 and around 1101. This was probably in the motte-and-bailey style, with a wooden castle built on a mound and surrounded by a wooden palisade. The Tawe was a strategically important river that required a highly visible symbol of the new rulers in control. The replacement stone structure would have been more durable, although Welsh insurgents damaged it on several occasions during uprisings. (*Above: The Alan Jones Collection. Below: Rebecca Gwynn*)

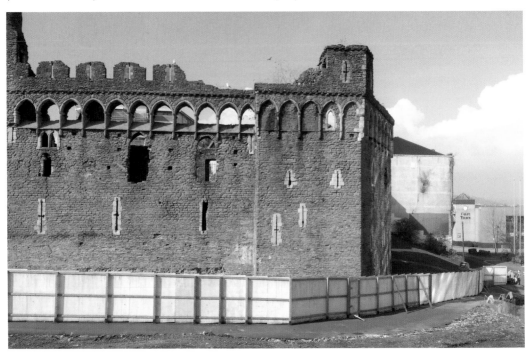

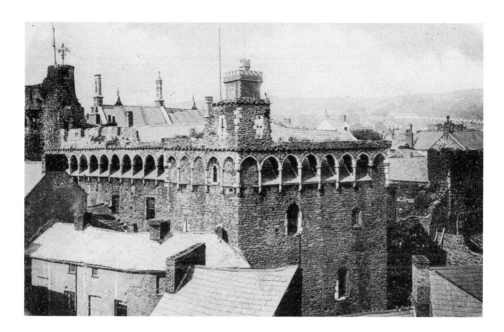

Swansea Castle, c. 1900

What remains of the castle dates largely from the early fourteenth century, when the Bishop of St David's adapted the building to form a palace similar to that already in use at St David's in Pembrokeshire. After several hundred years of neglect and being hidden behind other buildings, work is going ahead to make the castle site more accessible to the public.

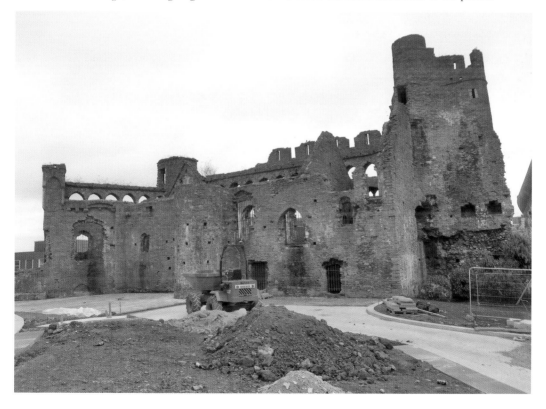

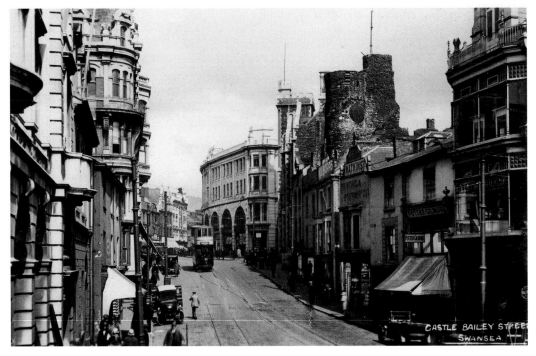

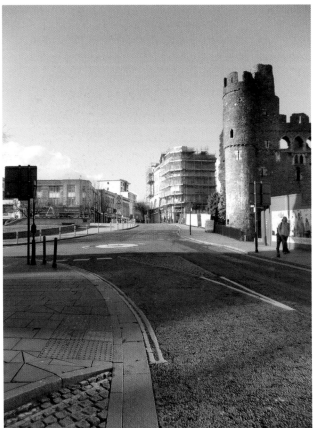

Castle Bailey Street, *c.* **1910**
Castle Bailey Street is a short street that links Castle Street with Wind Street. As its name suggests, it lies close to the castle wall. The Gothic-style tower fronting the castle was opened as Swansea's new head post office in 1858, and continued in that role until 1901, when a larger head post office was opened in Wind Street. The building later became the offices of the *South Wales Evening Post*, and was finally demolished in 1970.

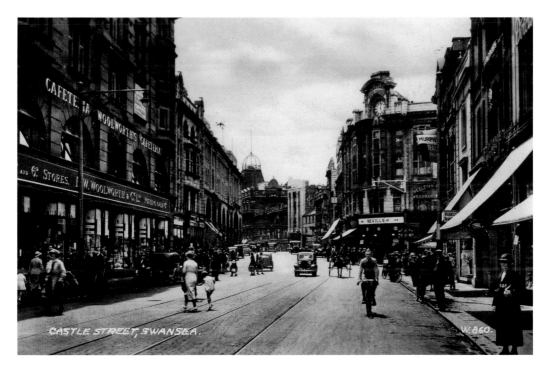

Castle Street, Looking South, 1938
At this point, High Street meets Castle Street at the junction, with College Street to the right and Welcome Lane to the left. Looking along Castle Street, the left-hand side is dominated by Castle Buildings and at the far end, in Castle Bailey Street, the ornate building that was Ben Evans Department Store can be seen.

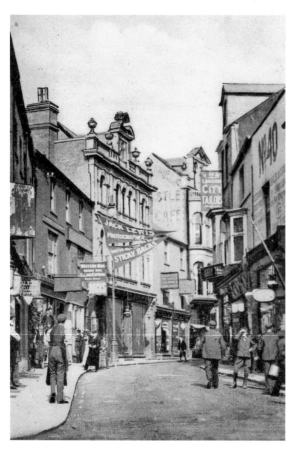

Castle Street, Looking North, 1910
Castle Buildings were built in the late 1920s, replacing a jumble of shops on the eastern side of the road. Notice the studios of Jack Lewis, photographer, whose work can still be found in family albums throughout Swansea. By around 1950, this part of Castle Street had been rebuilt as a wider street with cleaner lines.

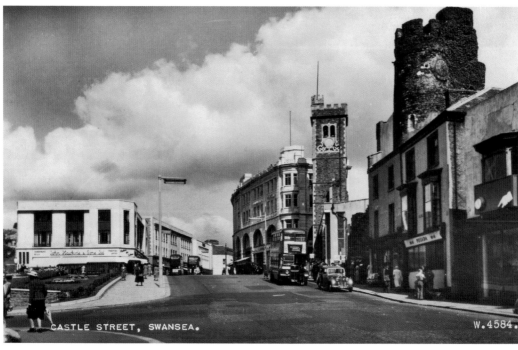

CASTLE STREET, SWANSEA. W.4584.

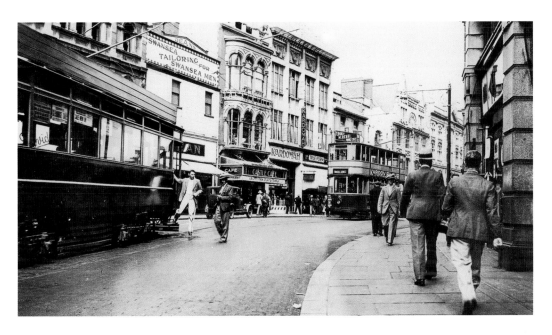

Castle Street, *c.* 1925, Showing the Kardomah Café
In the 1930s this iconic eatery was the haunt of a bohemian group of friends known as the 'Kardomah Boys', which included Dylan Thomas and Vernon Watkins. In Thomas' words, it was 'razed to the snow' in the Blitz. 2013 is Dylan Thomas' Centenary Year, and there will be celebrations throughout the year and throughout the city. The last of the Kardomah Boys – Charles Fisher – died in 2006.

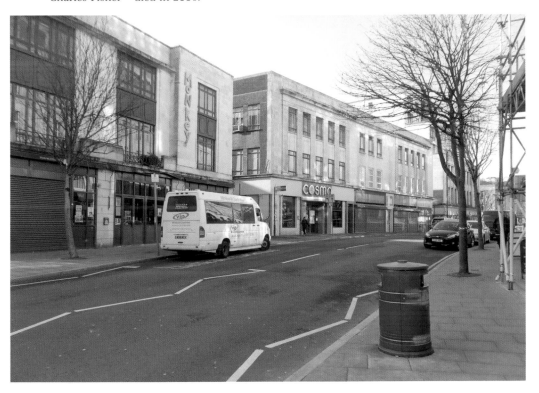

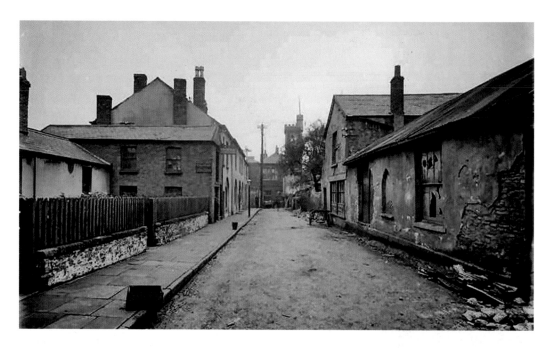

Worcester Place, *c.* 1920

Worcester Place runs parallel to Castle Street, between there and the Parc Tawe complex. In the 1920s, looking along the street towards the castle, the buildings were dilapidated, and those on the right were soon demolished and replaced with Castle Buildings. Today, the street is little more than a service alley for those premises and Laserzone that occupies the old Castle Cinema. (*Above: The Alan Jones Collection*)

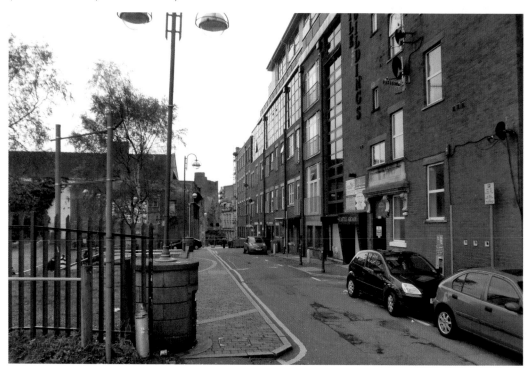

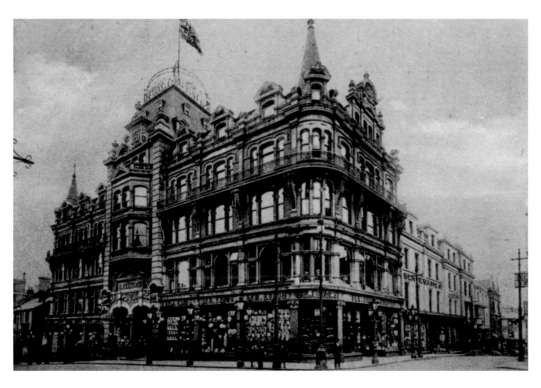

Ben Evans Department Store, 1906
On the western side of Castle Bailey Street stood the large, and very well known, department store of Ben Evans. The ornate building was a notable landmark. Sadly, the Blitz of 1941 completely destroyed the complex. This site is now Castle Gardens.

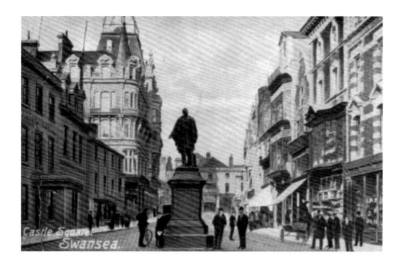

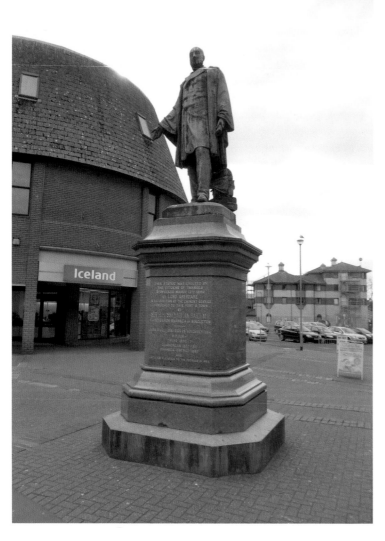

Castle Square, 1904
Situated at the point where Castle Bailey Street joins Wind Street, Castle Square was created when Island House, which stood in the middle of the road at the top of Wind Street, was demolished. The statue is of Sir Henry Hussey Vivian, who was a local industrialist and MP, and became 1st Baron Swansea in 1893. This statue now stands in St Mary's Street, adjacent to St Mary's church, having stood in Victoria Park from 1936 to 1982.

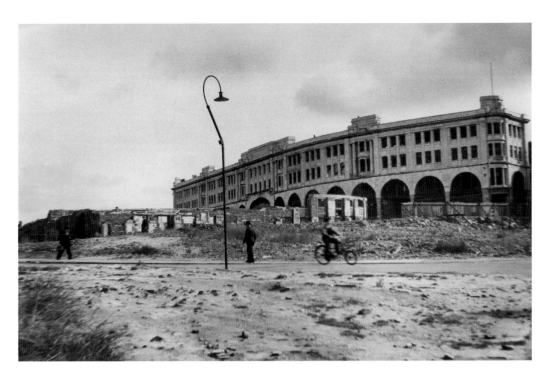

Castle Street and Castle Buildings after the Blitz, 1941
The three-night Blitz of February 1941 dealt a series of heavy blows to the town. As the commercial heart of the town was close to the docks, it received a huge payload of bombs. The streets between St Mary's church and the castle were flattened, and, as can be seen, left the people of the city with a desolate town centre.

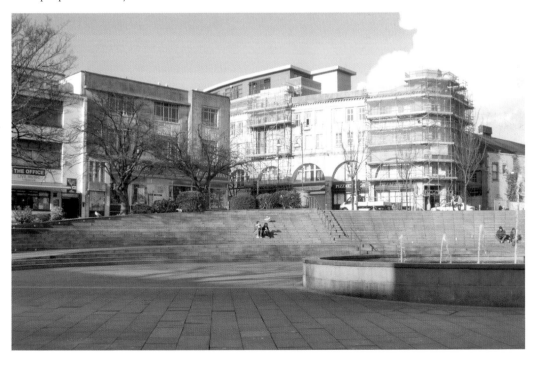

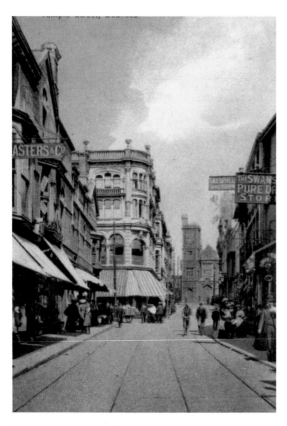

Temple Street, 1906

Temple Street ran from the junction of Castle Bailey Street and Castle Street down to the junction of Oxford Street and Goat Street. Ben Evans store occupied much of the southern side of the street. Today, the street is just a wide pavement, with Castle Gardens on the southern side, and Slaters, the Office and Inspirations on the northern side. The office is a bar, with seating outside.

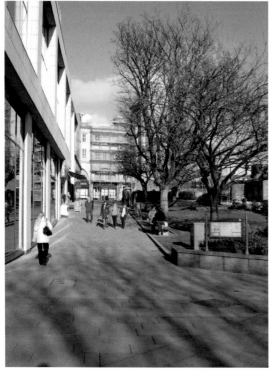

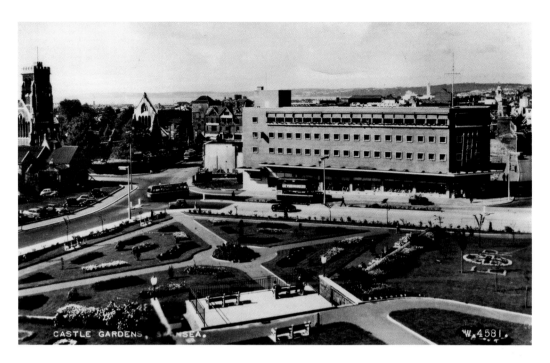

Castle Gardens, *c.* 1950

As part of the redevelopment of the centre of the town, open spaces were included, inspired arguably by the 'Garden City' movement of the 1930s. Castle Gardens were an oasis of lawns and flowerbeds with pathways and seats. Today, the plants have gone and the area is paved with a water feature and a 'Big Screen'. In the background, notice that St Mary's church still stands in ruins.

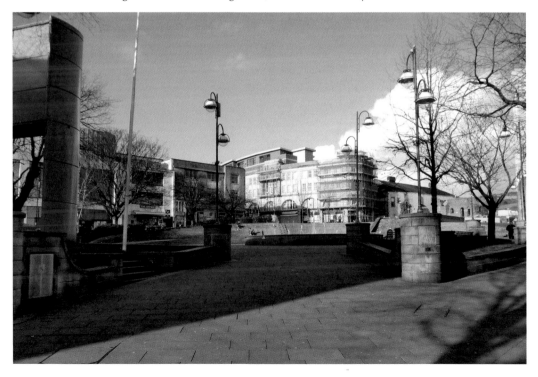

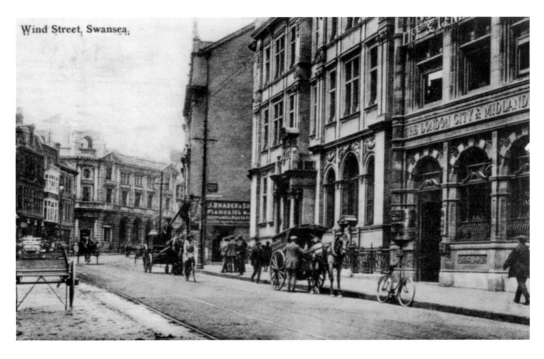

Wind Street, Swansea.

Wind Street, *c.* 1905

Wind Street is one of the original medieval streets of Swansea, known in Tudor times as Wyne Street, which best reflects the pronunciation of the name. It was here in the late nineteenth century and early twentieth century that most banks established their local head offices, creating a street of substantial office buildings. Today, it is the heart of the clubbing scene, and most of the office buildings have become pubs, clubs and places to dine.

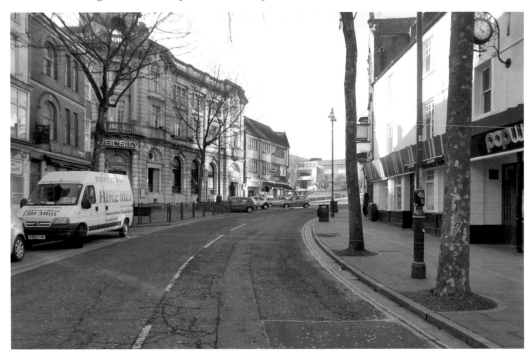

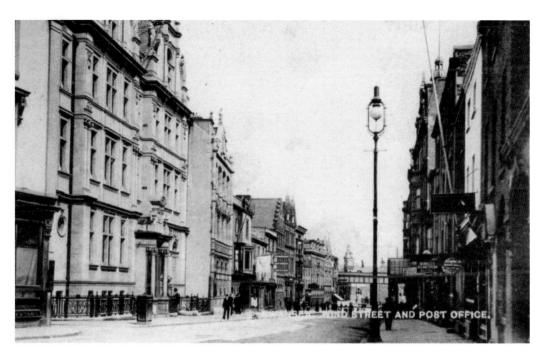

Head Post Office and Wind Street, 1917

In 1901, a new head post office was opened in Wind Street, on the site of the former Mackworth Arms Hotel. Behind this building was the sorting office, with vehicle access from The Strand. Today, the building is home to Idols nightclub and the Royal Mail have a brand new sorting office in Llansamlet. At the bottom end of the street the railway bridge, carrying the line from Swansea Victoria station to Swansea High Street station, can be seen.

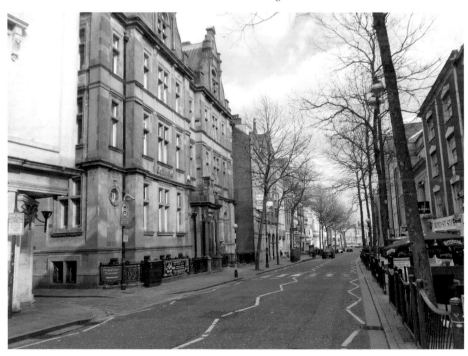

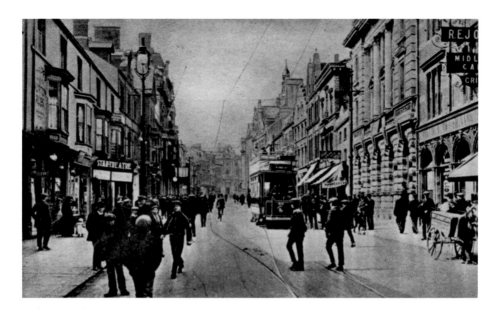

Wind Street, *c.* 1906

The lower end of Wind Street is in many ways reminiscent of the Wind Street of today, with many public houses and cafés. Note also the Star Theatre, which was owned by the impresario Andrew Melville until his death in 1896, after which his fifteen-year-old son, also Andrew, ran the establishment for a short time before a manager, William Coutts, took over. In 1905, he also became manager of the Palace Theatre in High Street. The Midland Railway Café on the extreme right is one of several establishments throughout Swansea owned by R. E. Jones.

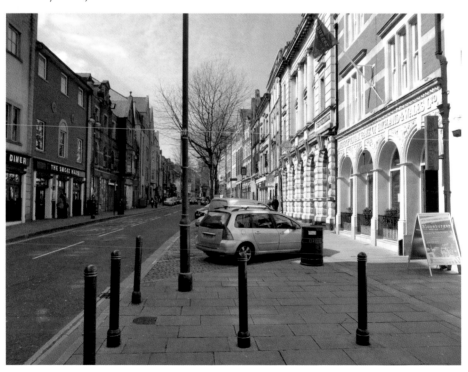

Cross Keys Inn, *c.* 1920

Built in 1332 as the Hospital of the Blessed
David of Swansea, the Cross Keys Inn is the
oldest surviving occupied building in the
city. It has been altered and expanded over
the years, but at its core remains a medieval
building. It also makes claim to be the
oldest public house in Wales.

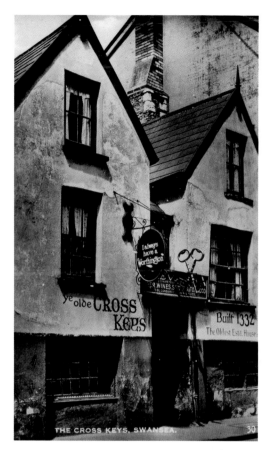

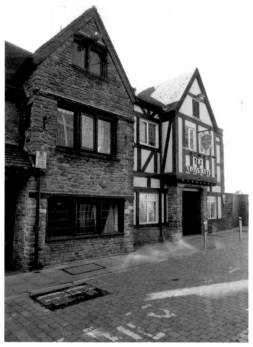

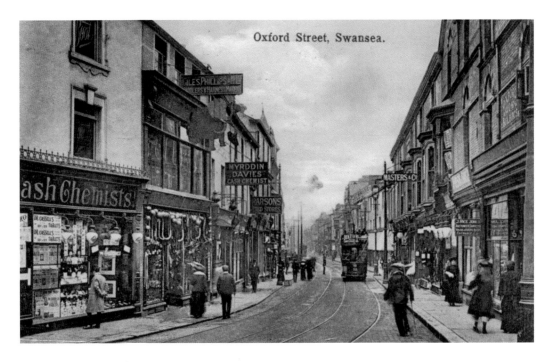

Oxford Street, Swansea.

Oxford Street from Boots Corner, 1913

The corner of Oxford Street and Princess Way has been known as Boots Corner for over a hundred years. Boots the Cash Chemist had its Swansea branch here from the time they opened in the town. After the Blitz, a new building was erected to house Boots, before moving into larger premises at the Quadrant Centre. The store they occupied is now a McDonalds restaurant.

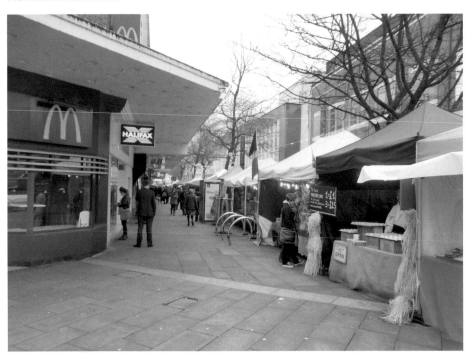

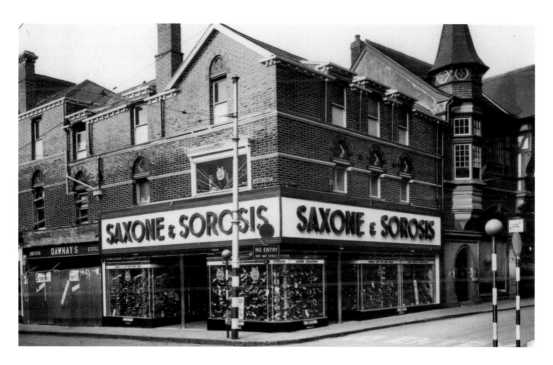

Saxone and Sorosis, _c._ 1930
On the opposite side of Oxford Street, on the corner with Goat Street, the shoe retailer Saxone &
Sorosis had a branch. Its approximate location is now occupied by Miss Selfridge.

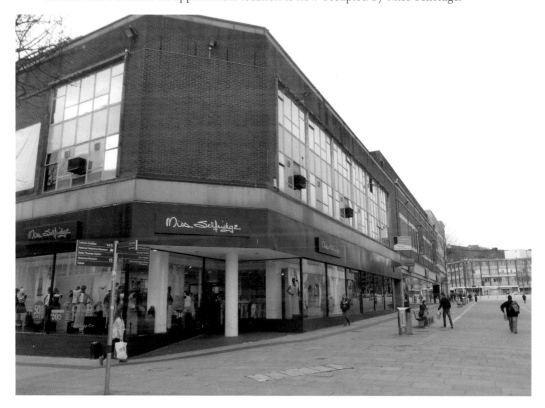

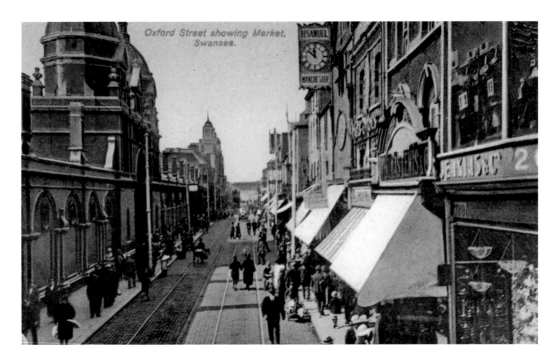

Oxford Street and the Market, *c.* 1910

Swansea has long been famed for its market. Before this imposing building was opened in 1894, there had been a market where Castle Gardens now lie, and a successor on the site of the Grand Theatre. This third market was to become the renowned one, but it, like much of Swansea, was destroyed in the Blitz. The traders carried on in the open air on an adjacent site until the present market was opened in 1961. The roof is to undergo extensive refurbishment in the not-too-distant future.

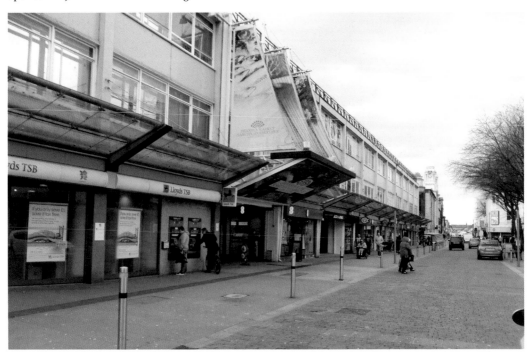

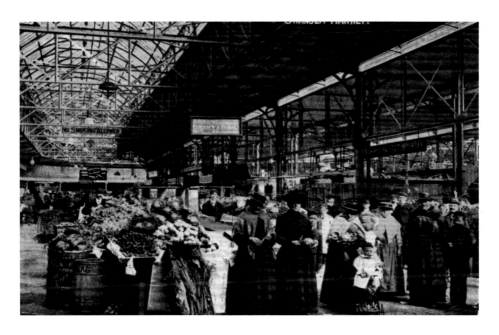

Interior of Swansea Market, 1916

Producers from all around Swansea and Gower came to the market to sell their goods, including vegetables, eggs, flowers, the world-famous Penclawdd cockles and much, much more. Today, the only Gower vegetable producer still with his own stall in the market is Neil Evans from Oldwalls.

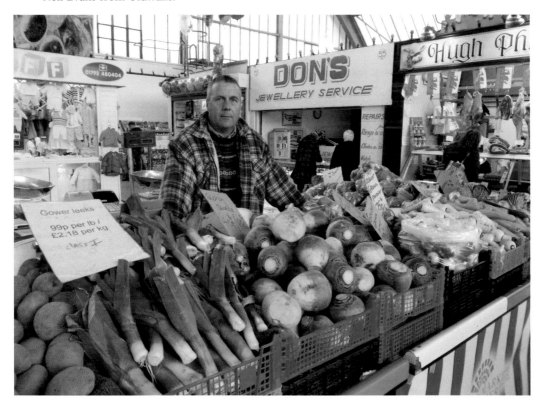

25

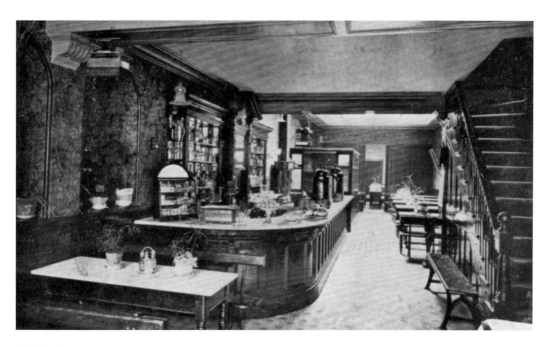

Market Restaurant, 1905
Mr Curran's restaurant was situated in the market hall, close to the Oxford Street entrance. Today, the café is situated in the centre of the market, and is open-plan, with the stalls all around.

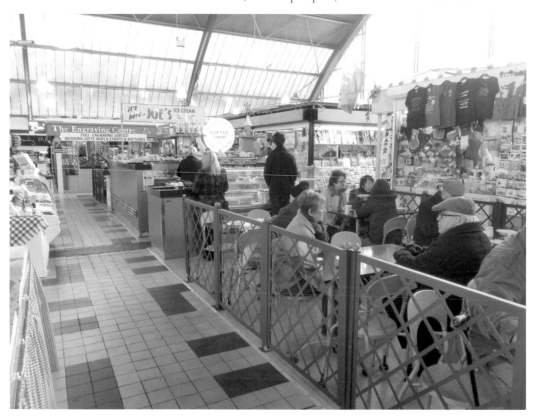

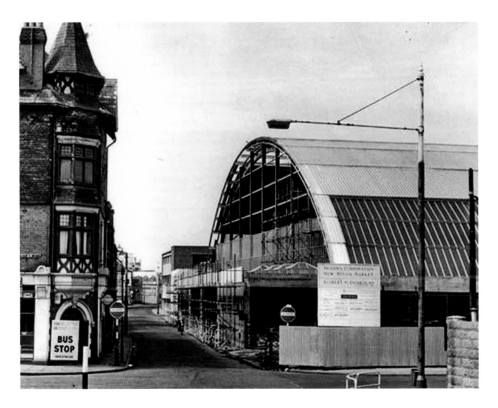

Orange Street, c. 1960

Orange Street ran parallel to Oxford Street, but on the southern side of the market. After the Second World War, it bordered, and provided access to, the open-air market. When Swansea's fourth market was built Orange Street provided access to the rear. The building of the Quadrant Shopping Centre, however, meant that it was relegated to the role of service yard for the new shops. (*Above: The Alan Jones Collection*)

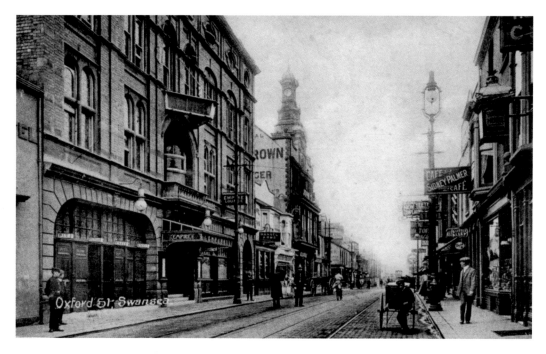

Oxford Street, *c.* 1905

Further westwards along Oxford Street stood the Empire Theatre, built in 1900 by Oswald Stoll. It was closed in 1957 and demolished in 1960. The site is now occupied by a 99p Stores. On the opposite side of the road there was a skittle alley alongside Sidney Palmer's café, and also a purveyor of false teeth!

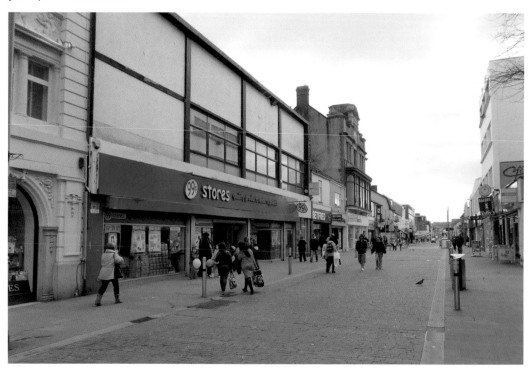

Carlton Restaurant and Cinema, 1919
Opened in 1914, next door to the Empire Theatre, the Carlton Cinema had an impressive façade, with a large bay window, behind which the stairs to the first and second floors were contained. These stairs led to the Carlton Café, which was another part of the R. E. Jones Café Empire. The cinema was closed in 1977, and the auditorium was demolished to make way for the building of the Waterstone's bookshop. The listed façade was retained and has been cleaned and restored to its former glory.

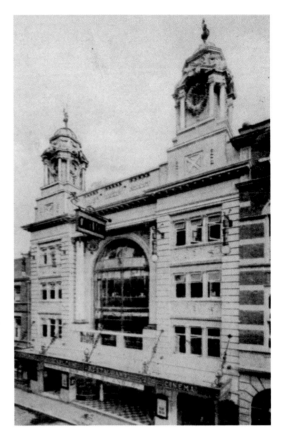

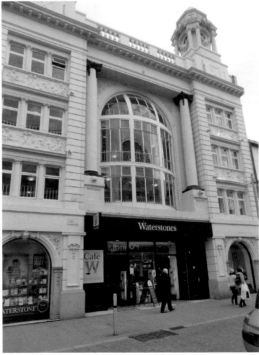

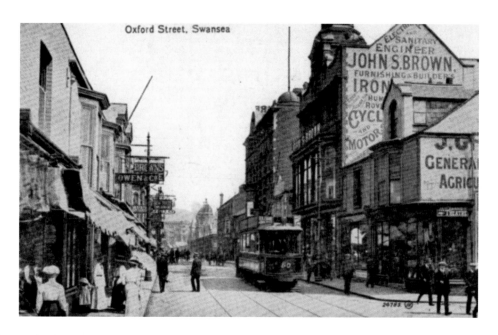

Oxford Street Looking East, *c.* 1905

Looking back along Oxford Street, one can see the distinctive domes of Swansea market. Beyond that, the clock tower of the old head post office can be seen at the top of Temple Street. The premises of John S. Brown on the right-hand side of the street still stands, being now occupied by Bonmarché. The premises on the corner are now a mobile phone repair shop. Notice also on the corner the sign pointing to the newly opened Grand Theatre, which would involve a short walk along Plymouth Street to Singleton Street.

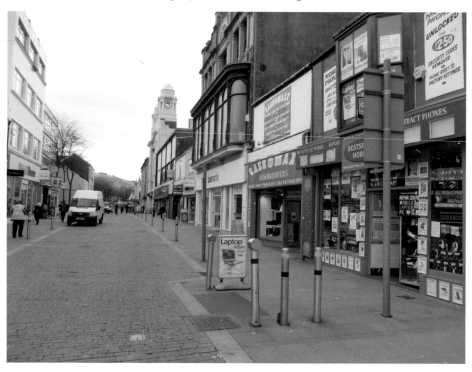

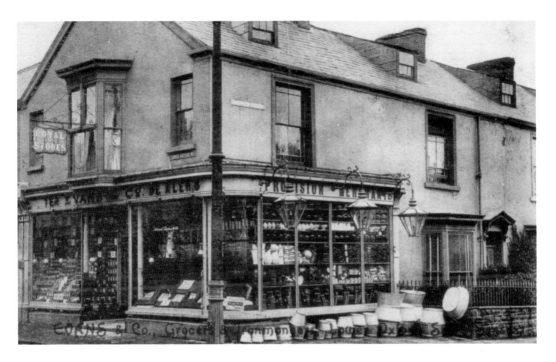

Royal Stores, Lower Oxford Street, 1905

The Royal Stores on Lower Oxford Street were typical of general stores of the time. Evans & Co. were described on the frontage as 'Tea Dealers' and 'Provision Merchants'; the postcard additionally describes them as 'Grocers & Ironmongers'. Obviously, here was a shop that sold just about everything! There were several general stores like this in the Sandfields area of Swansea.

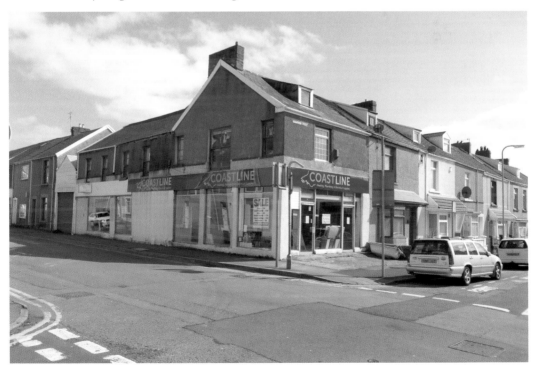

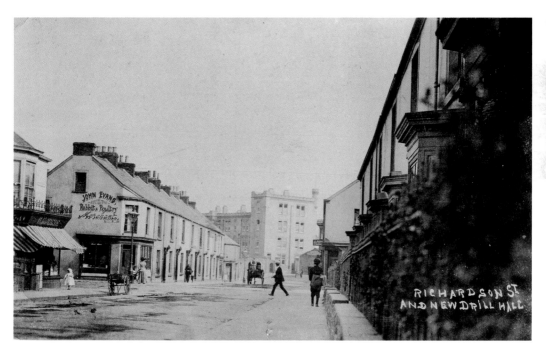

Richardson Street and the New Drill Hall, 1915
The Drill Hall at the end of Richardson Street was built to replace the old Drill Hall that had stood on Singleton Street, which had been demolished to allow the Grand Theatre to be built.

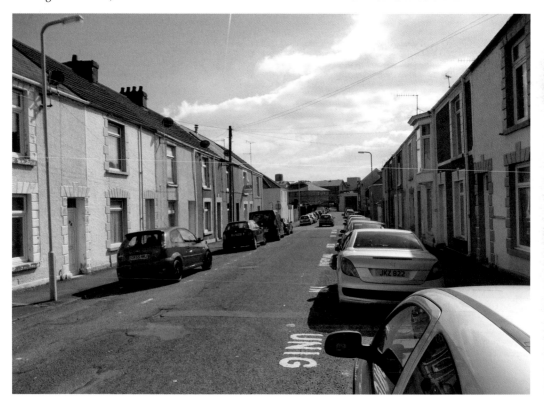

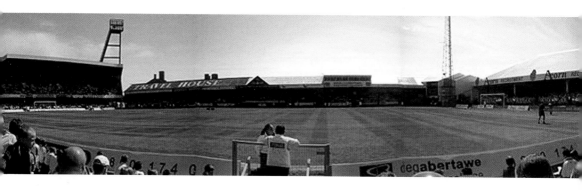

The Vetch Field, 2004

Home to Swansea Town AFC, then from 1969 Swansea City AFC, the Vetch Field was last used for a Football League game on 30 April 2004. The stands were later demolished and the site intended for new housing. However, the site has instead become a community asset, partly grassed over and partly occupied by the Vetch Veg Project, whereby local people have created allotments and gardens. (*Above: Courtesy of Swansea City Football Club*)

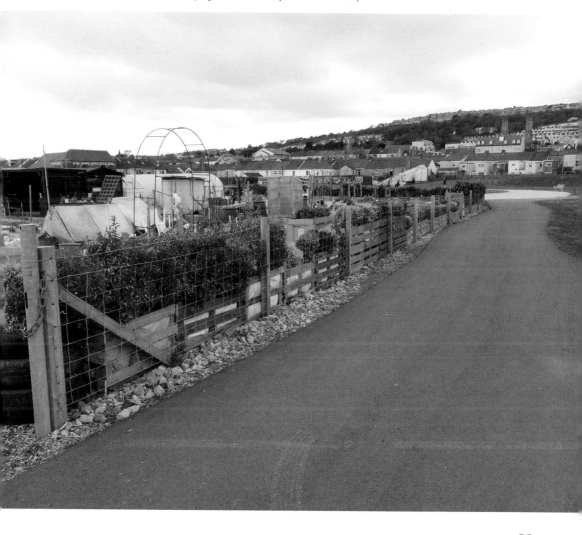

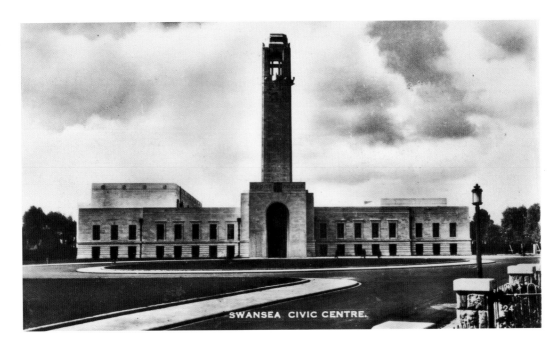

SWANSEA CIVIC CENTRE.

The Guildhall, *c.* 1935

As the boundaries of the borough of Swansea were extended in 1918, the existing civic buildings proved quite inadequate for the demands being placed on them. After some years of deliberation, a site was chosen on the eastern edge of Victoria Park, and a new Guildhall built. Designed by Percy Thomas, an architect from Cardiff, it was opened by the Duke of Kent on 23 October 1934. The Brangwyn Hall houses the famed Brangwyn Panels, the work of Sir Frank Brangwyn originally intended for the House of Lords.

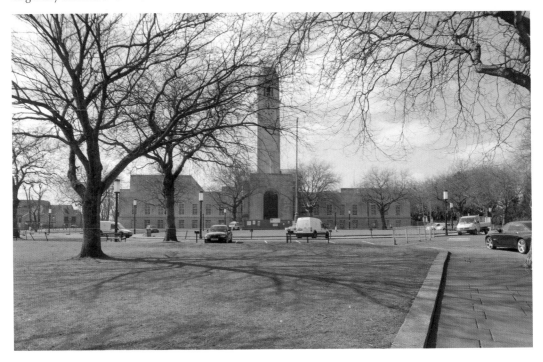

St Helen's Crescent, c. 1910
Before the new Guildhall was built in 1934, the houses of St Helen's Crescent looked out onto Victoria Park.

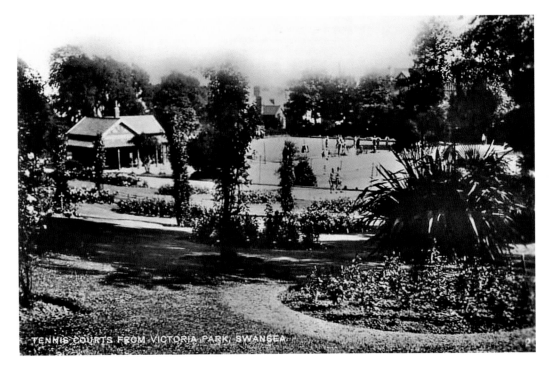

TENNIS COURTS FROM VICTORIA PARK, SWANSEA

Victoria Park, *c.* 1910

Although much reduced by the building of the Guildhall in 1934, Victoria Park still provides many facilities for use by the general public. There is a bowling green and a skatepark. Also note the large mural wall celebrating the life of Dylan Thomas.

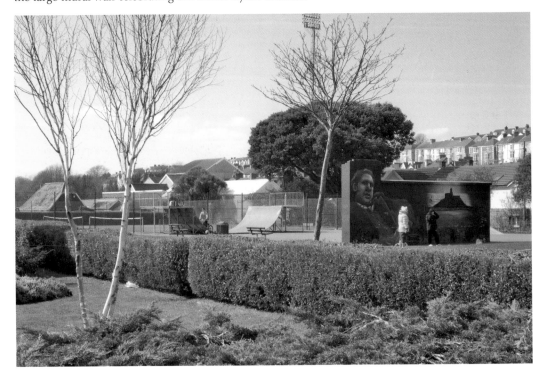

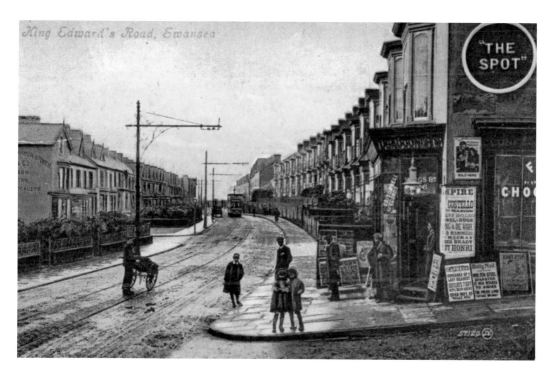

King Edward's Road, Swansea

King Edward's Road, 1915

The Newsagents and Tobacconists shop on the corner in the foreground certainly sold a wide range of items. In addition to tobacco products, newspapers and chocolate, they sold Edisonbell records. The *Daily Mail* of the day was leading with a disaster at a steelworks, where seventeen men were killed by a spillage of molten steel. The *Daily Express*, on the other hand, was more interested in the romances of a lady bigamist!

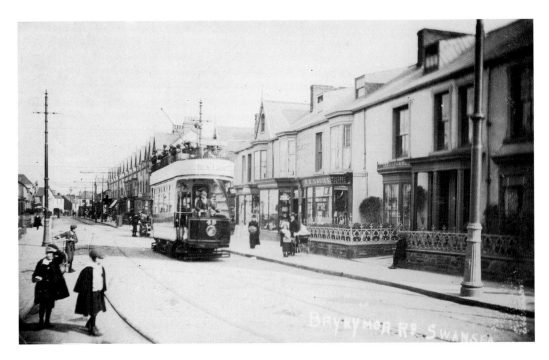

Brynymor Road, 1906

Just as today, in 1906 Brynymor Road was a busy shopping street. At this time though, the premises on the right, leading around to King Edward's Road, were still dwellings, whereas today they are all shops. Notice the crowded 4B open-topped tram – by far the quickest way to travel around the town, even in those un-congested days.

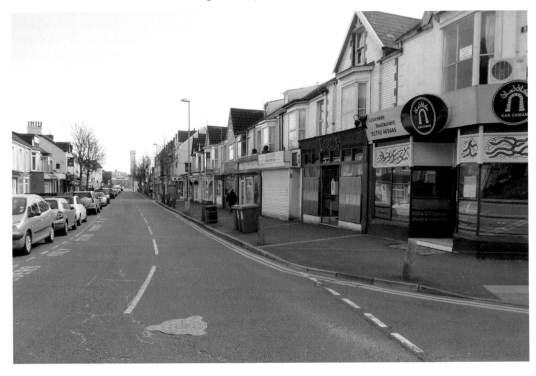

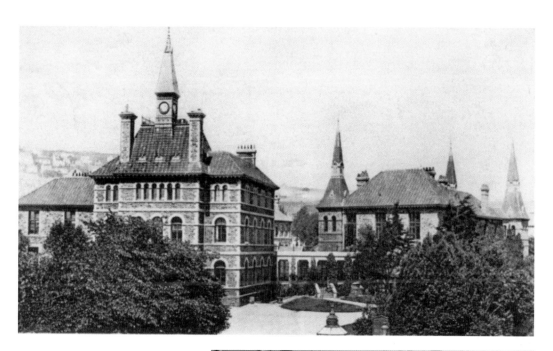

Swansea Hospital, 1903
First founded in 1814 as the Swansea Dispensary, then it became known as the Swansea Infirmary between 1817 and 1867. From 1872 to 1889 it had the title Swansea Hospital, and from then to 1948 was called the Swansea General and Eye Hospital. It was closed in 1968 and was replaced by Singleton Hospital. Converted into flats for older people, it is now called Homegower House.

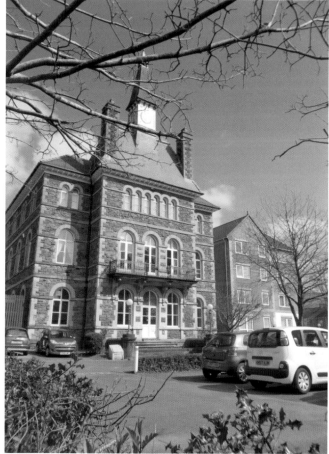

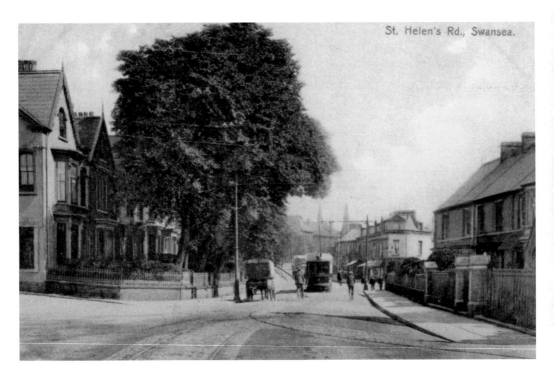

St Helen's Road, Western End, 1905

St Helen's Road is a long road, stretching from Oystermouth Road to Kingsway. Along its length it passes the Guildhall, the old hospital and a myriad of shops and restaurants. Trams ran its full length. Most of the buildings on the right-hand side in this 1905 view are still in place, albeit much altered. At its junction with Oxford Street, Joe's Ice Cream Parlour can be found.

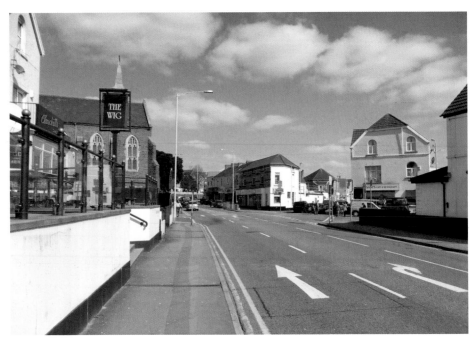

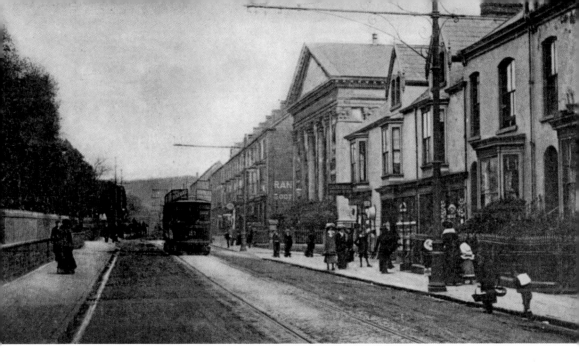

St Helen's Road, *c.* 1905

St Helen's Road has always been a busy arterial road with shops and offices mixed with residential properties. The colonnaded building is the Argyle Presbyterian Chapel. Closed before the year 2000, it was being converted into flats in 2002 when it was damaged by fire. That conversion was successfully completed and the building does now house flats.

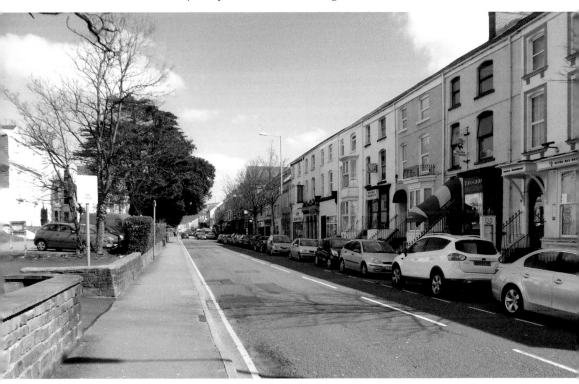

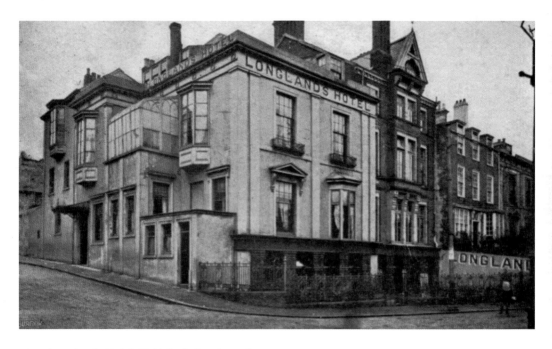

Longlands Hotel, St Helen's Road, 1906
The Longlands Hotel was situated at the junction of Page Street and St Helen's Road; the site was acquired in 1911 by the Swansea YMCA, who had outgrown their premises in Dynevor Place and needed a larger home. Local architect Glenn Moxham designed the building that still stands on this site.

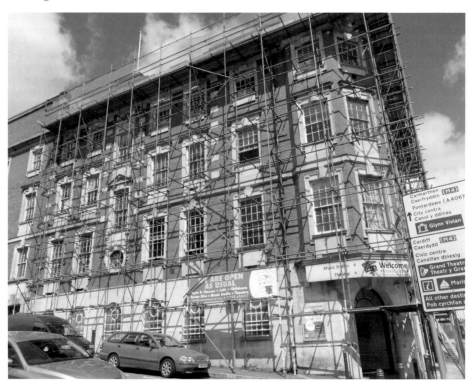

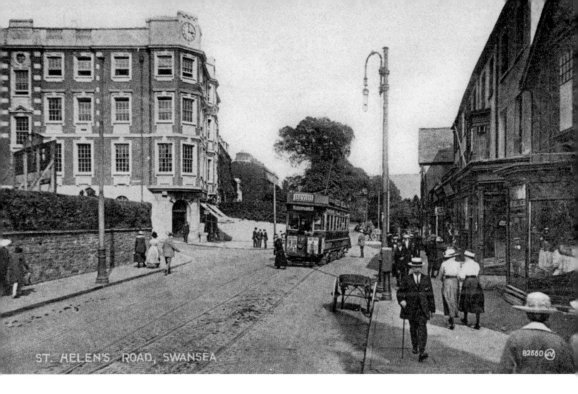

ST. HELEN'S ROAD, SWANSEA.

St Helen's Road and the YMCA, *c.* 1915
The new YMCA stands proudly at the end of St Helen's Road, dominating its immediate neighbours. The shops on the right-hand side of the road have mostly been replaced with more recent buildings. The mass of trees in the distance hides the villas of Northampton Place.

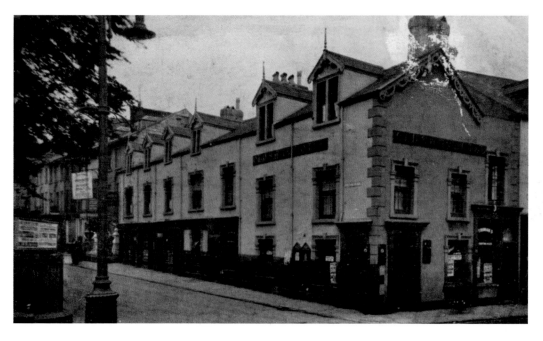

Old Swan Hotel, Gower Street, *c.* 1908
Gower Street disappeared as a result of the Blitz of 1941. However, we know that the Old Swan Hotel was on the corner of Dynevor Place and Gower Street, and that opposite it was the Mount Pleasant Baptist church. Today, the Dragon Hotel occupies the same site.

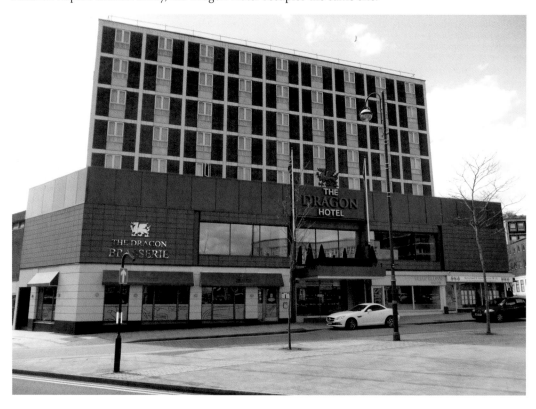

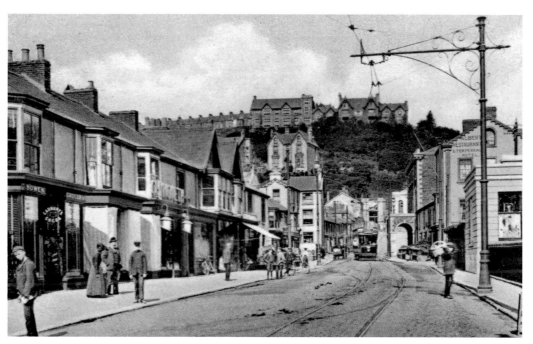

Cradock Street and the Deaf and Dumb Institute, 1908
There have been a number of changes to Cradock Street over the years. The building on the right closest to the camera made way for a branch of the Trustee Savings Bank, which is now part of the Lloyds TSB Banking Group. Further along on the right can be seen the portico of the Albert Hall. This opened as a cinema, and operated as such until around 1980, before becoming the Top Rank Bingo Hall, which was later transformed into a Mecca Bingo Hall until its closure in 2007. The building is now derelict, although efforts are ongoing to restore and reopen it.

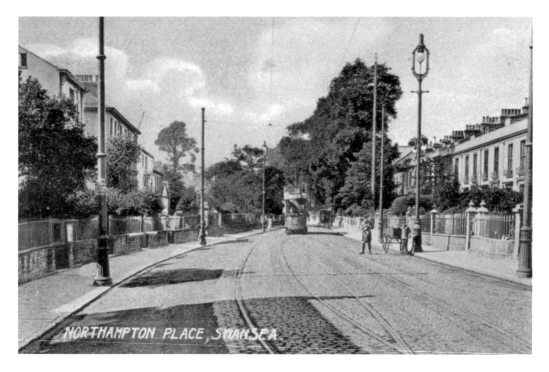

Northampton Place, 1909

This pleasant street of villas and town houses was actually closer to the centre of town than might at first be assumed. The high trees hide the YMCA building on St Helen's Road, and behind the photographer is Gower Street. The whole area was destroyed in the Blitz and today is part of the Kingsway.

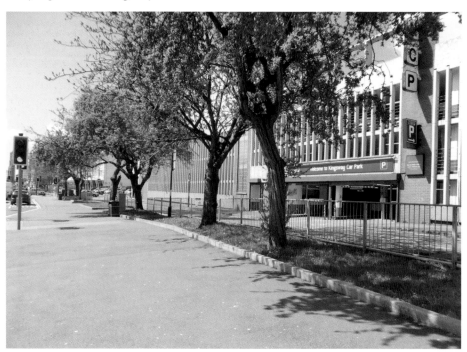

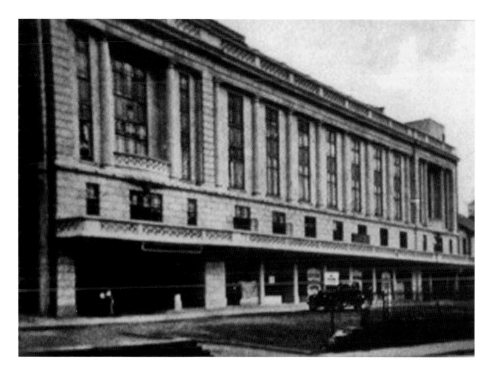

Plaza Cinema

The Plaza was the largest cinema to have then been erected in Wales, opening in 1931. It was the first independent cinema in Wales to have Cinema Scope and Stereophonic sound, these being fitted in 1953. The cinema was closed in 1965 and was demolished to be replaced by the Odeon. The Odeon in turn was closed and became a nightclub. (*Above: The Alan Jones Collection*)

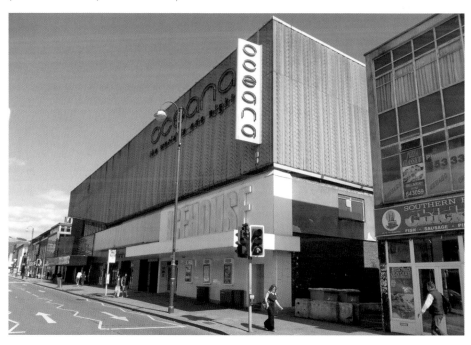

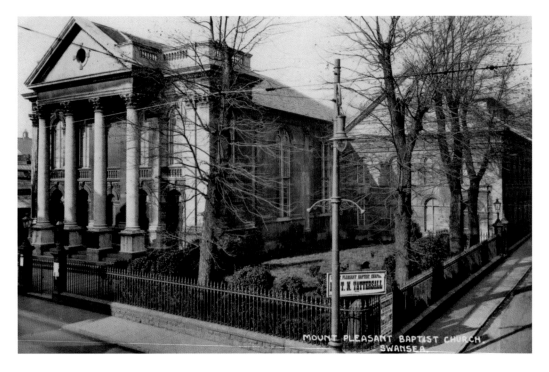

Mount Pleasant Baptist Church, *c.* 1910
This church was built in 1825/26 and was successively enlarged in 1874–76, 1885, 1904 and 1904/05. It fronted Gower Street, with Dynevor Place running along the right-hand side in this view. The Old Swan Hotel is just out of the picture on the right. It is still a thriving church today.

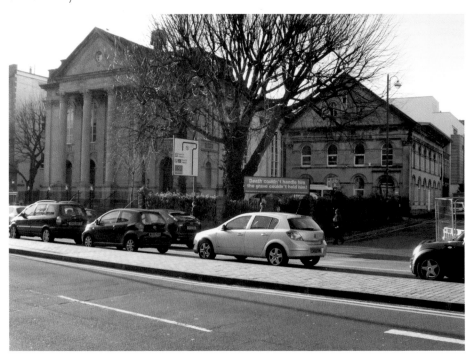

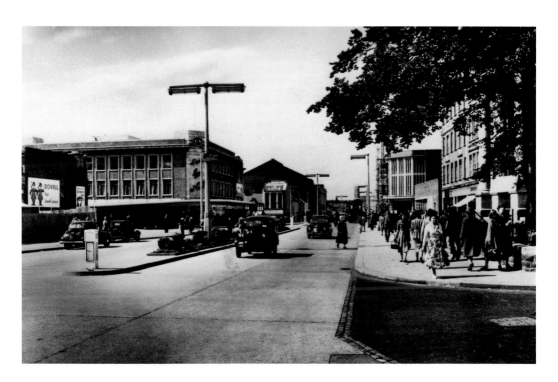

Kingsway, Looking West, c. 1950

This view, taken from the junction with Dynevor Place, shows just how much rebuilding was required after the Second World War. Gower Street and Northampton Place both vanished and were replaced by the broad dual carriageway that is Kingsway, a name it was given to honour King George VI. Some new buildings have been completed, but there was still much to be done, as witnessed by the hoarding at the junction with Portland Street.

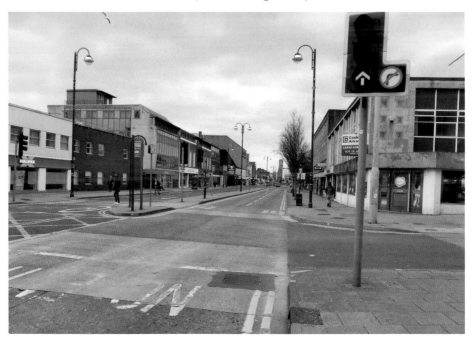

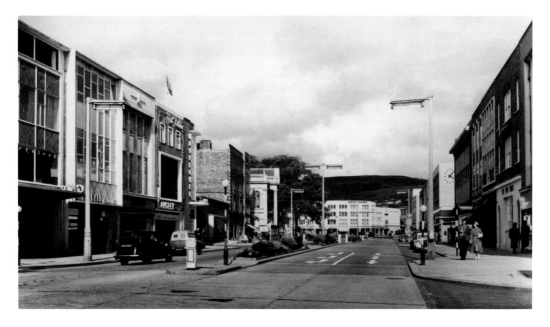

Kingsway, Looking East, *c.* 1960

Taken ten years later than the previous view of Kingsway, this image shows that the rebuilding had continued and now the Morris Buildings, completed in 1956, stand at the junction with Portland Street resplendent with a clock. Beyond the Mount Pleasant church, the trees hide an open space that served as a temporary car park. John Hall (Tools) Ltd, on the left-hand side here, was a mecca for small boys in the 1960s as they had a toy department on the first floor with a wonderful array of Tri-ang model railways.

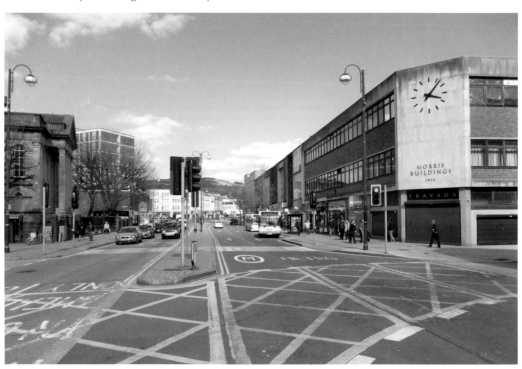

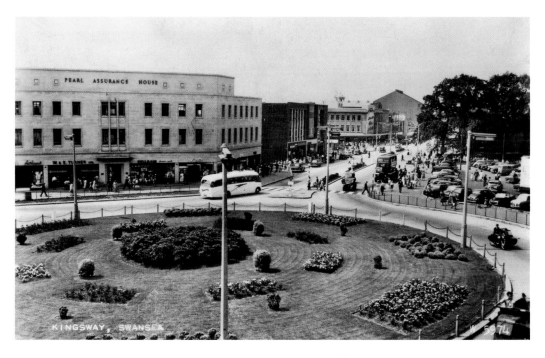

Kingsway Roundabout, c. 1960
This view of the roundabout at the end of Kingsway shows the temporary car park mentioned previously. Pearl Assurance House dominates the roundabout, and has not changed, other than the tenants of the shops. The roundabout has undergone several changes, being a pedestrian underpass with a sunken central paved area for a number of years. Today, this has all become a through road, redesigned as part of the changes made to accommodate new 'bendy' buses in 2011. The temporary car park is now the site of the prestigious Dragon Hotel.

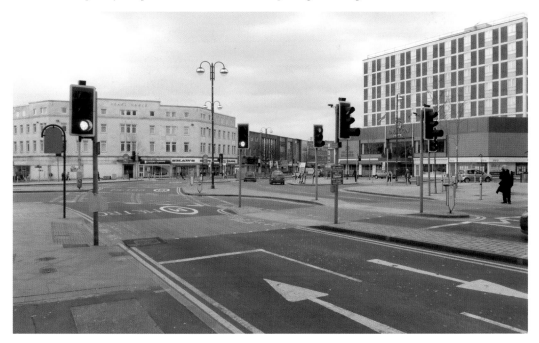

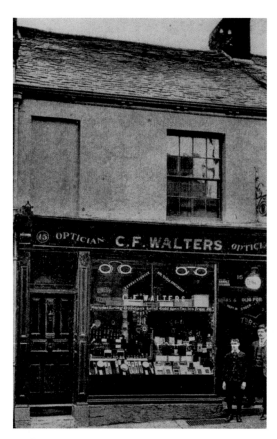

C. F. Walters, Optician's, Union Street,
c. 1905
The long established local optician's,
C. F. Walters, had their first premises at
No. 15 Union Street. Still going strong,
they now trade from a more up-to-date
establishment in Mansel Street. The
Union Street shop is currently empty,
but, judging by the notice on the door,
will soon be a branch of Paddy Power, the
Irish chain of bookmaker's.

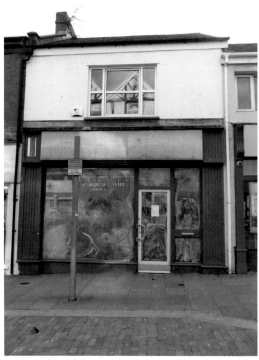

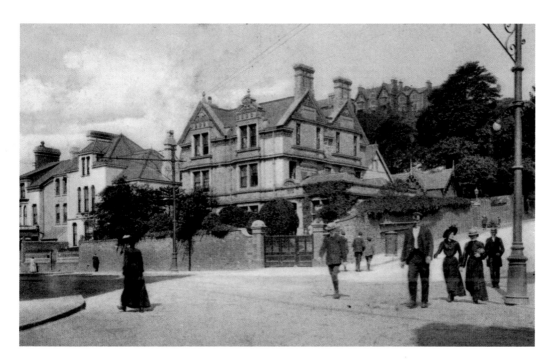

Mount Pleasant and De La Beche Street, 1907

Mount Pleasant Hill climbs from De La Beche Street up to Townhill and Mayhill. Halfway up was the Technical College, which previously had been Swansea Grammar School, *alma mater* of Dylan Thomas. Today it is part of Swansea Metropolitan University. Out of the picture to the left stood Dynevor School, the buildings of which, since closure, have also become part of Swansea Metropolitan University. Pedestrians today could not be so casual about crossing the road, as this is now a busy junction.

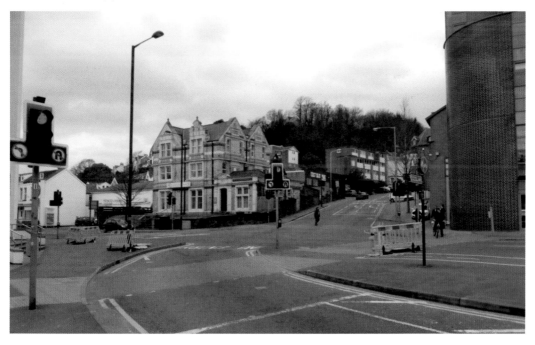

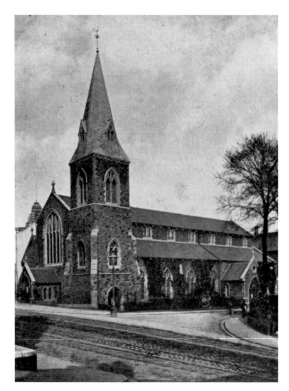

Holy Trinity Church, *c.* 1905
This church stood on Alexandra Road, at its junction with Pleasant Street. Founded in 1843, as the mother church of the parish of Holy Trinity, in 1936, the parish was combined with St Mary's. The church itself suffered some war damage, and ultimately was considered redundant. Subsequently, the building was demolished and the site is now occupied by sheltered housing.

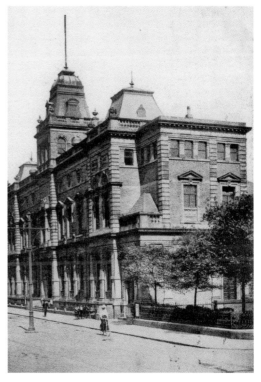

Free Library, *c.* 1912
Swansea Central Library combined both
a public lending library and a reference
library. Designed by Henry Holtom, it was
opened by W. E. Gladstone in 1887. The
reference library at the heart of the building
is circular with a domed roof. In 2007 the
building was closed pending the opening
of a new library at the Civic Centre on
Oystermouth Road the following year. The
empty building has been used by the BBC
for location filming for several episodes of
the television series *Dr Who*. The building is
currently undergoing a thorough renovation
as part of Swansea Metropolitan University.

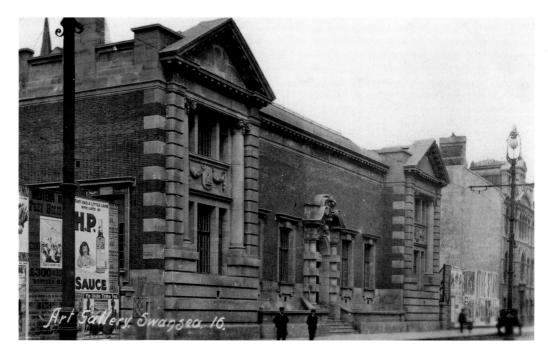

Glynn Vivian Art Gallery, 1922

Richard Glynn Vivian was a member of the Vivian family, who were local industrialists. In 1905 he offered his collection of drawings, paintings and china to the town. He endowed the collection with sufficient funds to create a gallery, laying the foundation stone in 1909. The design of the building was the work of Glenn Moxham, who was also responsible for the new YMCA. The building was closed for refurbishment in 2011, which explains why it is surrounded by fencing.

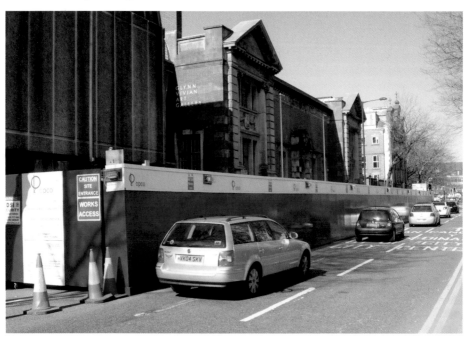

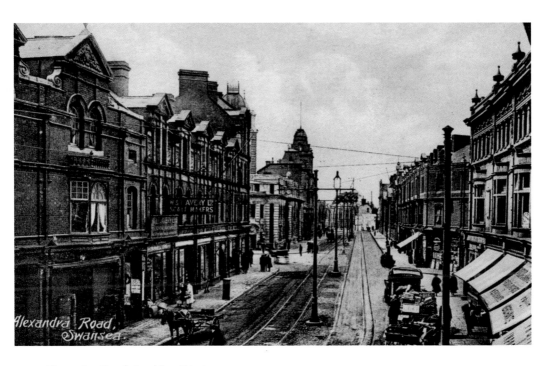

Alexandra Road, Looking West, c. 1910

In the middle distance can be seen the distinctive towers of the Central Library. The junction in the foreground is where Orchard Street crosses Alexandra Road. Adjacent to the library, the newly built police station can just be seen. To the right is the wholesale fruit and vegetable market, while opposite are the premises of Avery the weighing scale manufacturers. Almost all of this has disappeared, with just the police station and library surviving. Orchard Street is now a major route into the city.

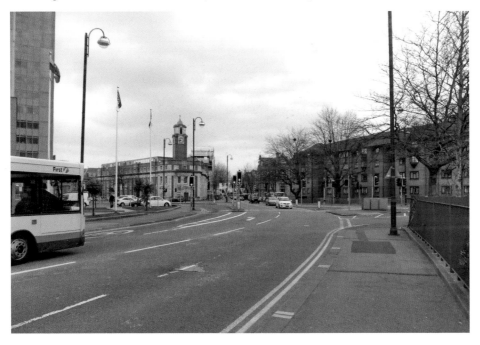

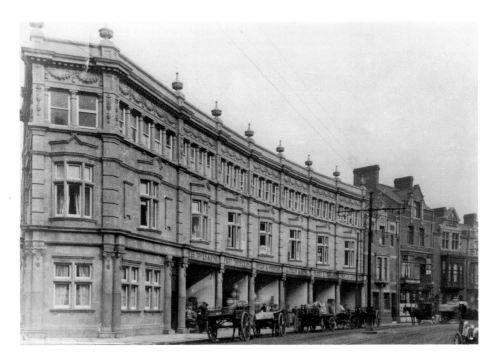

Wholesale Fruit and Vegetable Market, Alexandra Road, *c*. 1906
This view better shows the layout of this section of Alexandra Road. The wholesaler's carts are lined up awaiting loading. The nearness to Swansea High Street station meant that fruit and vegetables coming in by rail could easily be transferred to the wholesale market. This whole block has now gone, and in its place there are car parks. The wholesale fruit and vegetable presence in the area has not quite disappeared, as F. Ley & Son still has premises close by.

Alexandra Arcade & Jubilee Arcade, c. 1905

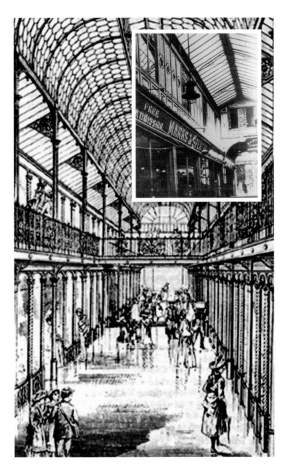

The Alexandra Arcade ran from Orchard Street to High Street, and was opened in 1890. It was a high glass-roofed structure, which was light and airy. However, redevelopment of this part of High Street meant the closure of the arcade and its demolition in 1972. In its place arose Alexandra House, which has become something of a landmark in the city.

The inset picture is of the Jubilee Arcade, which ran from Waterloo Street to Goat Street. Marks & Spencer opened their first store here in 1902. The arcade was destroyed in the Blitz, and the site is now occupied by the BHS store. Marks & Spencer are now next door in Oxford Street. (*Above: The Alan Jones Collection. Inset: Marks & Spencer*)

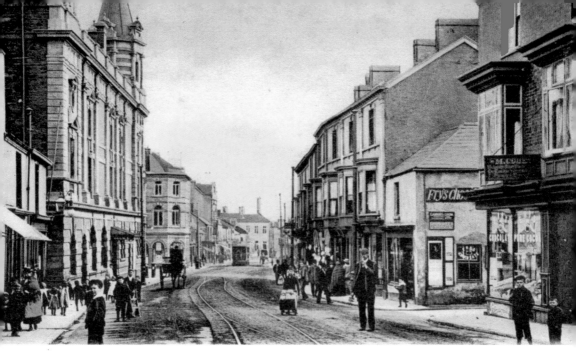

High Street and the Empire Theatre, *c.* 1901

The Pavilion Theatre of Varieties opened in 1888 on a triangular site at the junction of High Street and Prince of Wales Road. In 1892, it was renamed the Empire Theatre but in 1901 was renamed again as the Palace Theatre of Varieties. By 1908 it was screening films as part of the bill, and 1912 saw it being called the Swansea Popular Picture Hall and People's Palace. In 1923, it was back to live theatre and back to the Palace Theatre of Varieties. More change in 1937, when, as a cinema it was called the New Palace Cinema, then just the Palace Cinema. In 1954 it was live theatre again, and it was here, in 1960, that Sir Anthony Hopkins made his first professional appearance on the stage. A few years later it was a bingo hall, then a private club before becoming a nightclub as its last gasp before closure by 2007. The building is now derelict.

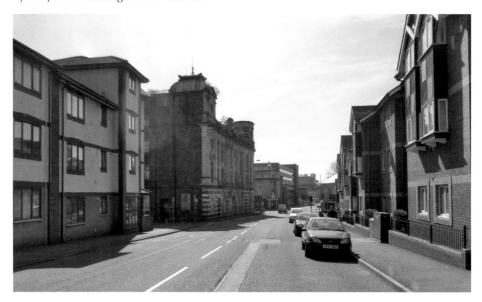

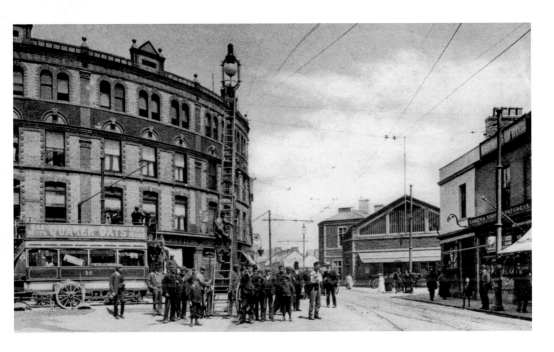

High Street Railway Station, *c.* 1910

High Street Railway station was opened in 1850 by the South Wales Railway, under the supervision of Isambard Kingdom Brunel. In 1863, the South Wales Railway amalgamated with the Great Western Railway, which in turn was nationalised in 1948. Recently the station has undergone a £7.6 million facelift that has improved not only the look of the station, but added facilities for the travelling public.

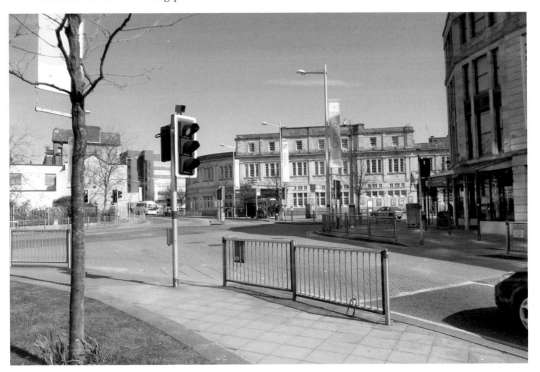

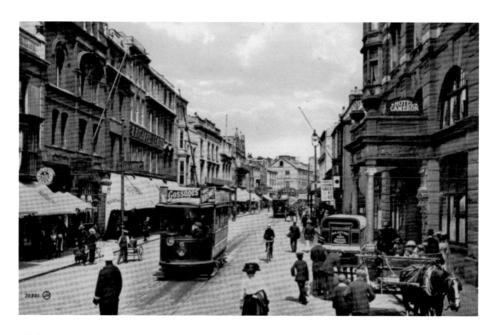

High Street, c. 1905

High Street was a busy shopping street in the early years of the twentieth century, with the Hotel Cameron an unmistakeable presence. F. W. Woolworth had their Swansea branch at the end of the street, and many people frequented their first floor cafeteria. War damage, and indeed the needs of progress, meant that much of the street was redeveloped. Woolworths remained, in a new building, which is now occupied by Argos. Today, trees have been planted and the area given a facelift to make it more appealing to shoppers.

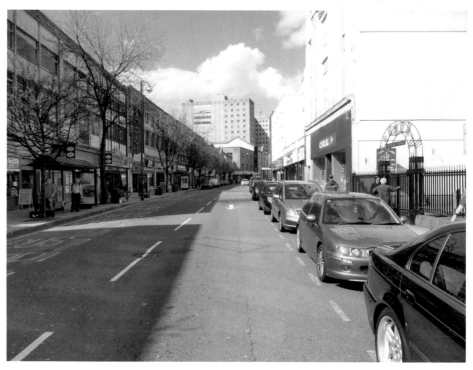

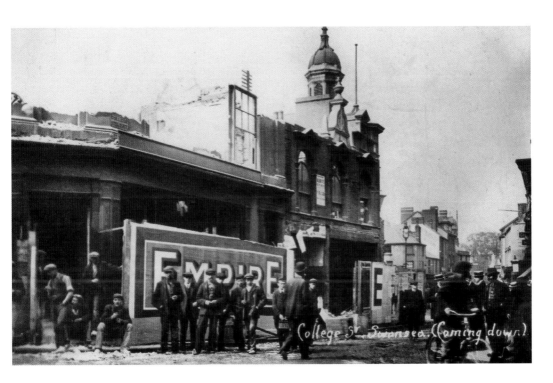

College Street, c. 1920
College Street is a short street that links High Street with Kingsway. At the time this photograph was taken, some demolition work was in progress, although the new building would have had a short life as the whole area was destroyed in the Blitz. Notice that the Empire Theatre (in Oxford Street) took advantage of the temporary hoarding to gain some publicity!

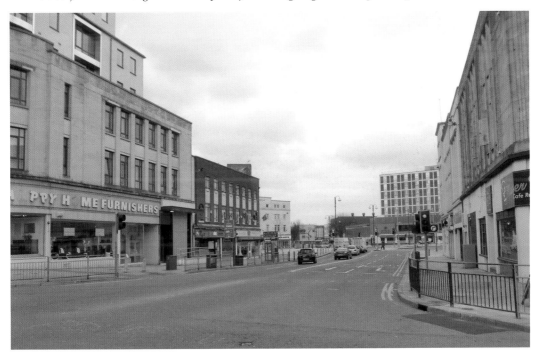

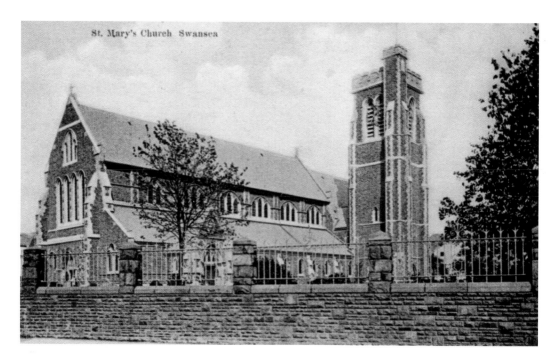

St. Mary's Church Swansea

St Mary's Church, c. 1910

St Mary's church was founded in the twelfth century, but has undergone several restorations and rebuilds in its history. Between 1895 and 1899 an impressive Gothic-style building, designed by Sir Arthur Blomfield, replaced the previous, much criticised, structure. The church suffered considerable damage during the Blitz, and was rebuilt between 1954 and 1959 by L. T. Moore and Sir Percy Thomas, who followed Sir Arthur Blomfield's original design plans.

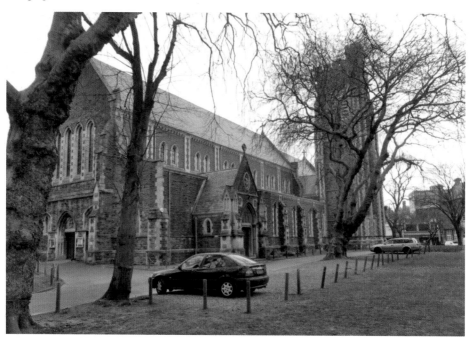

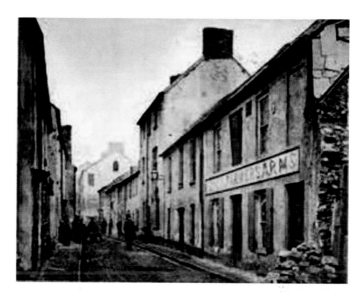

Frog Street, *c.* 1920
This street ran alongside
St Mary's church, and had
buildings on both sides,
some backing onto the
churchyard. Like the church
itself, these buildings were
destroyed in the Blitz,
and when the church was
reconstructed Frog Street
became part of St Mary's
Square. (*Above: The Alan
Jones Collection*)

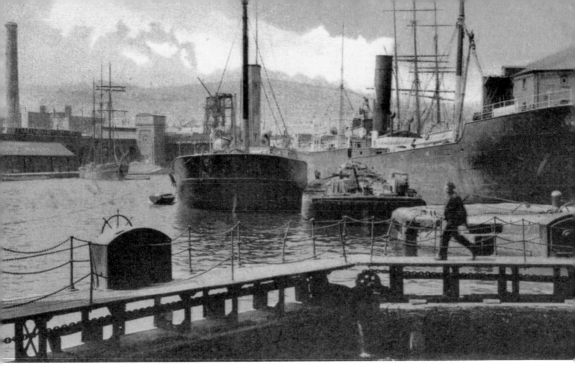

Entrance to the North Dock, 1905

The North Dock was created in 1852 by diverting the River Tawe, along a new cut. The bow of the river that was left became the new dock. The dock closed in 1930, as the larger docks that had been built on the east side of the river provided better facilities. Subsequently, the dock was filled in and in the 1980s the Parc Tawe retail park, along with Plantasia, was built on the site.

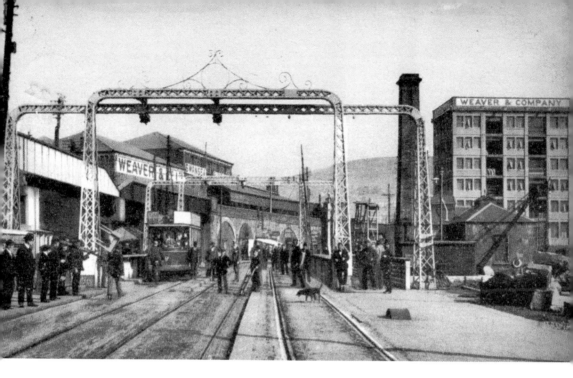

North Dock Drawbridge, 1910

This bridge crossed the entrance to the North Dock, with the dock itself on the left-hand side and the basin on the right-hand side. Weaver's flourmill dominates the area, as it had buildings on both sides of the road. Along the left-hand side can also be seen the high level railway line that linked Swansea Victoria station with Swansea High Street station. Today, all this has gone, to be replaced by Quay Parade and the two bridges across the river.

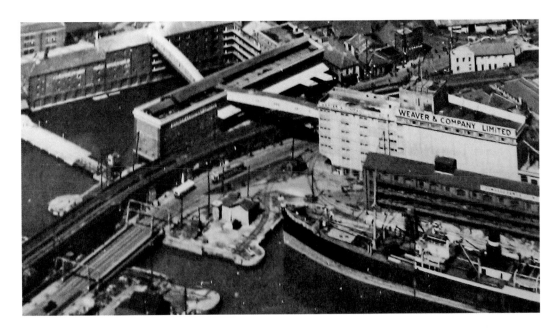

Weaver's Flour Mill, c. 1930

Weaver's Flour Mill was built in 1897 by the French engineer Francais Hennebique and was Europe's first reinforced concrete building. It stood alongside the basin of the North Dock, but also had buildings on the opposite side of the road, making a large complex. Despite its historical importance, and a campaign to retain it, the mill was demolished in 1984, at the time that the North Dock was filled in. The site is now occupied by Sainsbury's supermarket. (*Above: The Alan Jones Collection*)

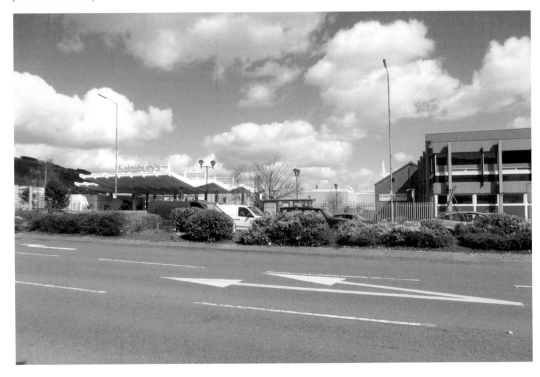

The Strand, c. 1920

The Strand, the road that ran alongside the river, and subsequently alongside the North Dock, was an important thoroughfare for much of Swansea's history. A variety of business premises, and residential properties, lined the road. Today, it has become little more than a service road, leading to the backs of a number of premises that front Wind Street and High Street. The BT tower dominates it, and there are also some empty office buildings along the road. It also has a role as a pickup point for late-night revellers. (*Above: The Alan Jones Collection*)

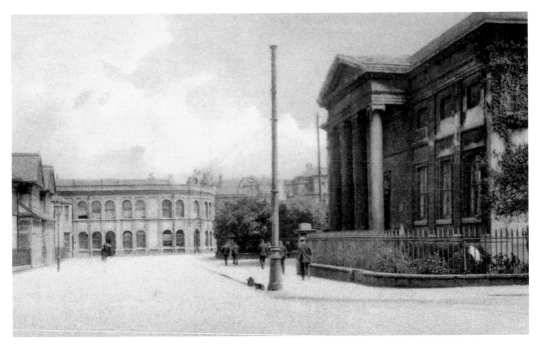

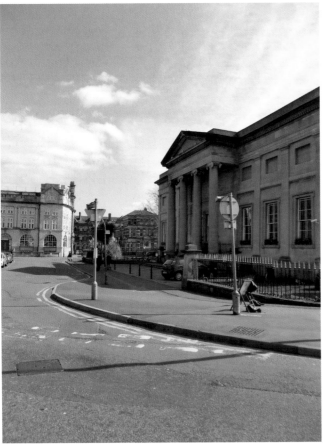

The Royal Institution,
c. 1910
The Swansea Philosophical
and Literary Society was
founded in 1835, with the aim
of researching and collecting
information on a wide variety
of topics, and then sharing
it with others. They built the
Swansea Museum to display
the items they had collected,
to create a library and to
have a lecture theatre so that
public lectures could be held.
The museum was transferred
in 1991 into the care of
Swansea City Council.

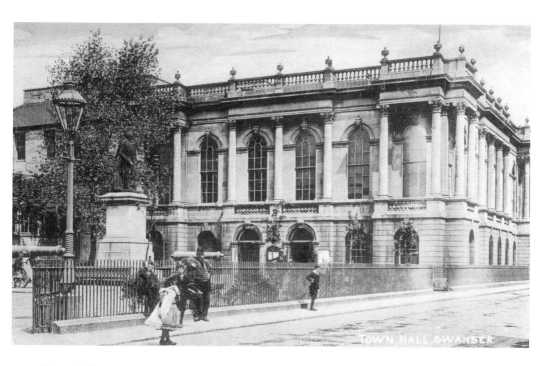

Town Hall, 1905

In 1825, it was decided that a new town hall was needed, and the site selected was in the area known as the Burrows. Work was completed in 1829, but by 1848 the building was deemed too small, and was enlarged into the building we now see. The statue of John Henry Vivian and the two Russian cannons captured during the Crimean War were later additions. Today, the building has been renamed the Dylan Thomas Centre and hosts exhibitions and events.

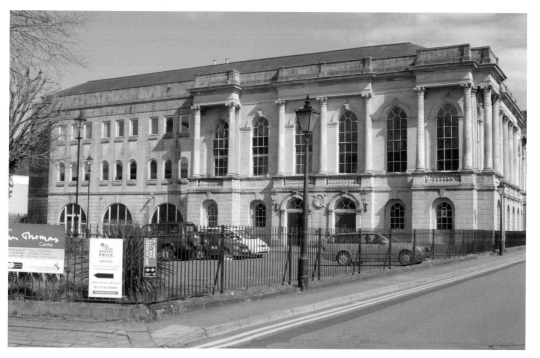

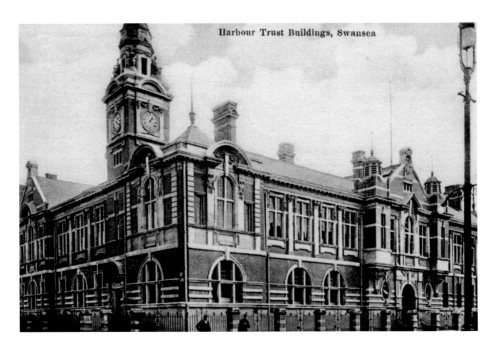

Harbour Trust Buildings, Swansea

Harbour Trust Buildings, *c.* **1910**
The Swansea Harbour Trust built these prestigious headquarters in Adelaide Street in 1903. Previously they had occupied offices in Mount Street, almost opposite the new building. Control of the docks at Swansea transferred to the Great Western Railway in 1923, and the Harbour Trust ceased to have a role. The building was sold in the 1990s and is now Morgan's Hotel.

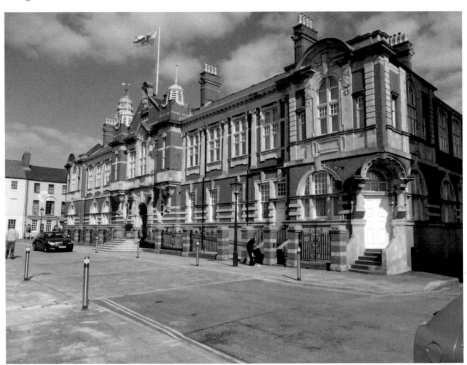

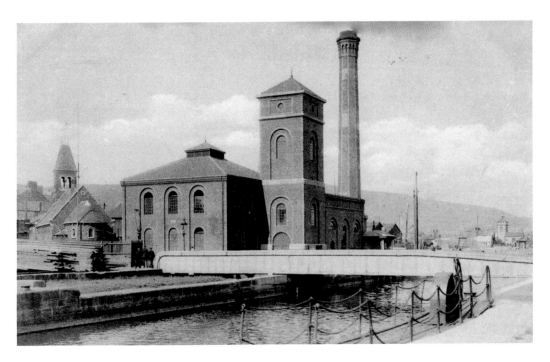

South Dock and Engine House, 1905

Construction of the South Dock began in 1852, undertaken by a private company, but the Harbour Trust had to take over the work, which continued until 1859. The engine house provided power for the lock gates, and although the chimney stack has gone, the building still stands, and is now the Pump House Restaurant.

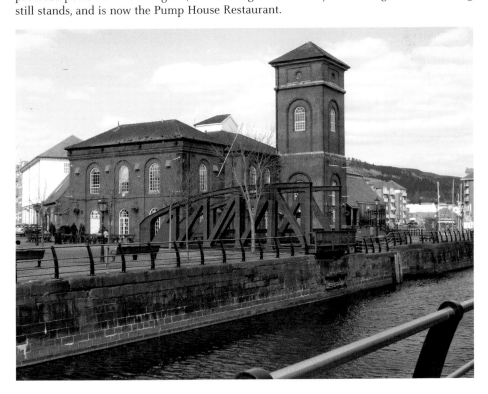

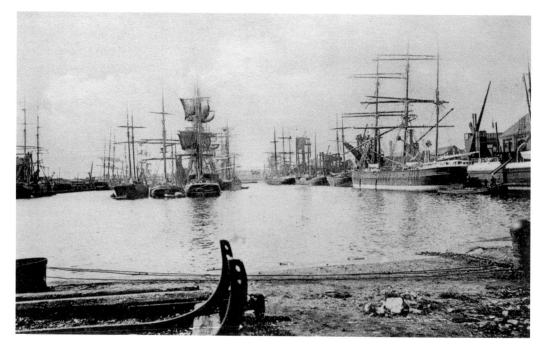

South Dock, c. 1905

The view of South Dock shows just how sailing ships dominated sea trade up until the beginning of the twentieth century. The South Dock was closed in 1971 and was earmarked for filling in and redevelopment. However, new proposals to create a marina in an effort to expand the tourist potential of Swansea met with approval, and the dock was cleared. Today it is a popular yacht haven and residential area. The Waterfront Museum occupies the one remaining old warehouse on the north side of the dock. At the western end rises Meridian House, the tallest building in Wales, which can be seen on page 82.

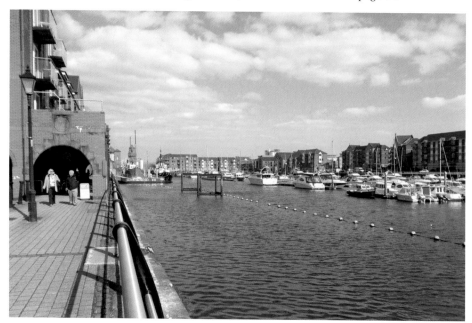

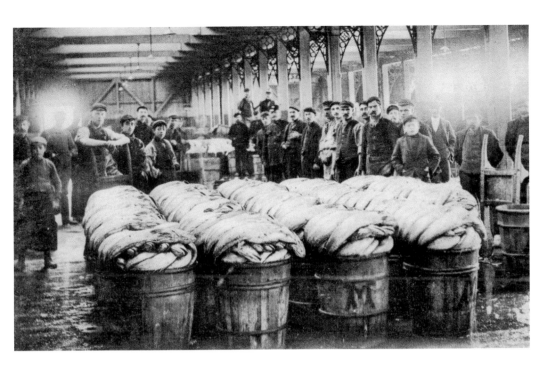

The Fish Wharf, South Dock, *c.* 1905
Fishing was an important industry in Swansea, and there was a dedicated fish wharf at the South Dock. Although all this has now disappeared, there is still one fish merchant based in what has now become the Maritime Quarter of the city.

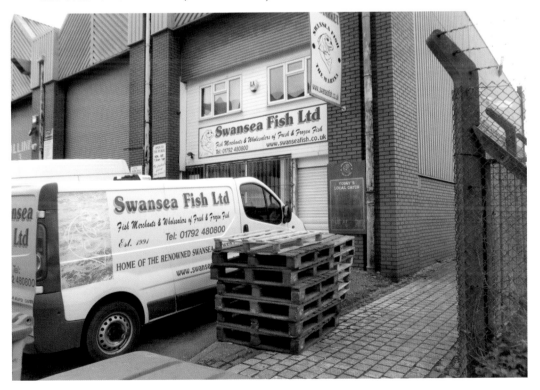

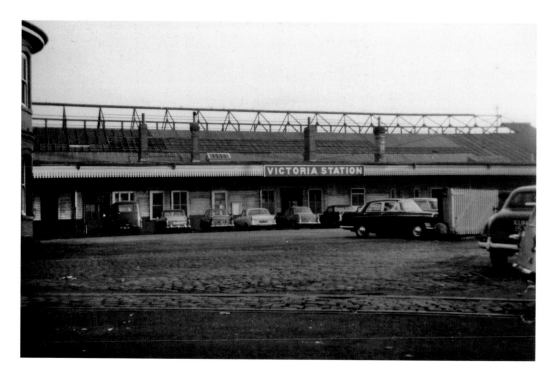

Victoria Station, c. 1950

In 1866 the Llanelly Railway brought its line into Swansea, coming down the Clyne Valley and along the shoreline. The goods station opened first, followed by the passenger station. From 1873, the London and North Western Railway owned the line, becoming part of the London Midland and Scottish Railway in 1923. Victoria station had an overall glass roof that was shattered during the Blitz and never replaced. Closure came as a result of the Beeching axe and the site is now occupied by the LC2 leisure centre.

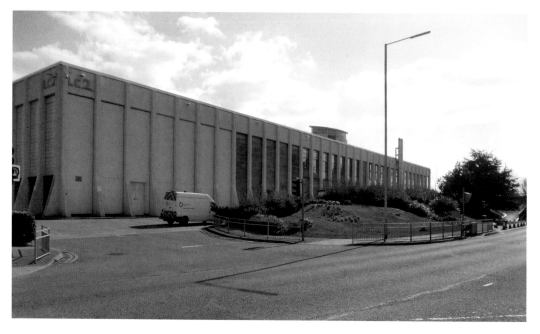

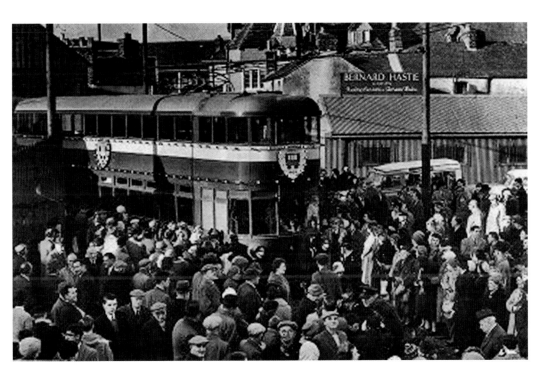

Mumbles Train Entering its Shed After its Last Run, 1960
The Swansea and Mumbles Railway was the first railway in the world to carry fare-paying passengers. It enjoyed enormous popularity during its lifetime, but was closed in 1960. Its sheds at Rutland Street were demolished and today the St David's multistorey car park occupies the site. (*Above: Courtesy of South Wales Evening Post*)

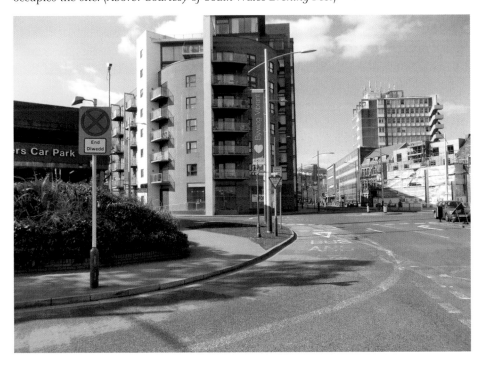

Oldway House, 2012/13

The Swansea cityscape is constantly changing and Oldway House is one case in point. This office block, which had housed a number of government and local government departments during its useful life, became surplus to requirements. The St David's Shopping Centre next door had also become a white elephant. The City Council, together with the Welsh Assembly Government, purchased the two sites and have demolished part of the St David's Centre, creating a surface car park in its place. Oldway House has also been demolished, although as yet has not been developed. In time, when the economic situation improves, it is likely that a retail or leisure development will bring the site back to life. (*Above: Rebecca Gwynn*)

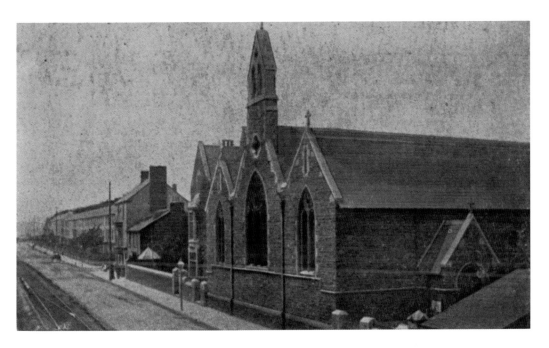

Christ Church and Trafalgar Terrace, c. 1905
Christ Church was started in a small way in a schoolroom in the Sandfields in 1863. In 1871 it was established as a separate parish. The building is much as it was when photographed in 1905, although, like many ecclesiastical buildings today, it is necessary for the windows to be protected against vandalism.

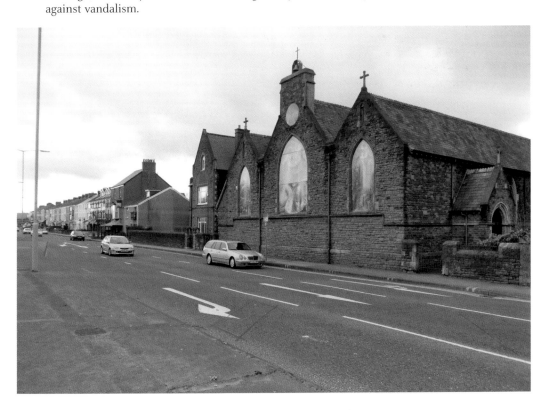

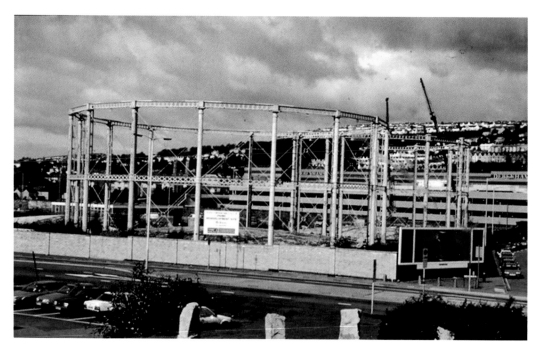

Gasworks, c. 1990

The gasworks on Oystermouth Road were opened in 1842, replacing a much smaller gasworks in Dyfatty. With the changes that were taking place in the gas industry in the latter quarter of the twentieth century, the gasworks became redundant. By 1990 demolition was under way, and the site is now occupied by Tesco. (*Above: Jason Williams*)

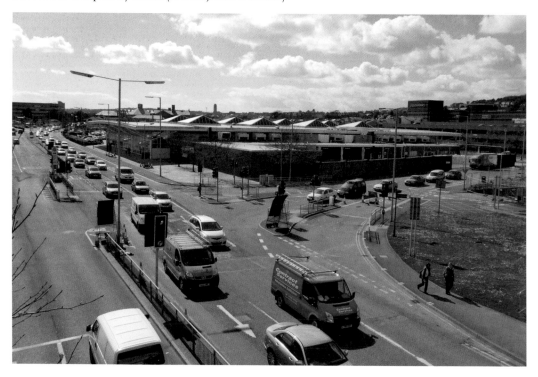

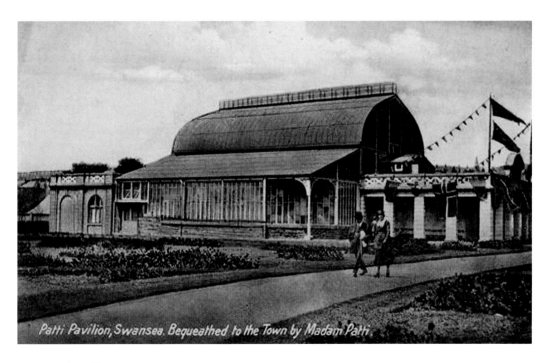

Patti Pavilion, Swansea. Bequeathed to the Town by Madam Patti.

Patti Pavilion, c. 1930
The Patti Pavilion began its life as the Winter Garden at the home of Dame Adelina Patti at Craig-y-Nos Castle near Abercrave. In 1917, she donated the building to the people of Swansea, and for many years it was used as a venue for dances, meetings, entertainments, etc. It has now been extended to incorporate the Patti Raj Indian Restaurant.

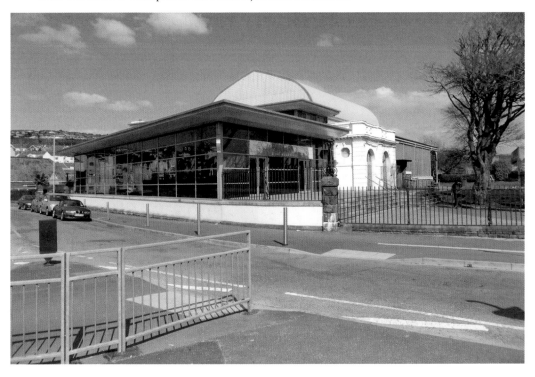

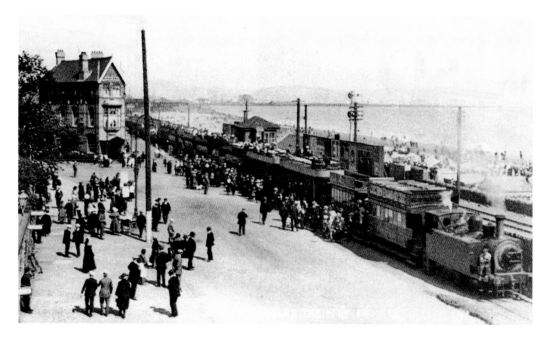

The Slip, c. 1906

The Swansea and Mumbles Railway was very popular and on high days and holidays thousands of people would travel to Mumbles to walk on the pier and frequent the funfair. Stops like the one at the Slip would be crowded with people waiting to catch a train, as this picture shows. With two adjacent railway lines, crossing to the beach was difficult, so a bridge, called the Slip Bridge was built. Today, just the abutments still stand at their original location, as the metal girder bridge has been taken away and is now in situ on the ground near the Cenotaph. Campaigners continue to agitate for its restoration.

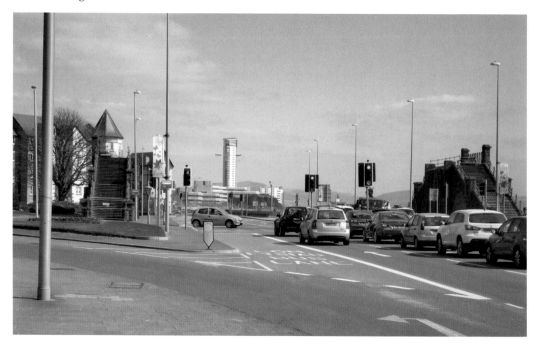

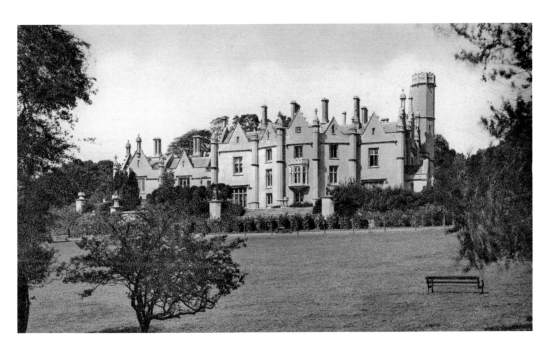

University, c. 1930

In 1920, King George V came to Swansea, and laid the foundation stone for the new university being created at Singleton Abbey. From the start, the University was groundbreaking, appointing the UK's first woman professor in 1921, and after the Second World War, creating a self-contained campus with all facilities on one site – another first. Today, anyone visiting the campus will enjoy the prospect, shown below, of Fulton House, named for the groundbreaking Principal J. S. Fulton, whose brainchild the single site concept was.

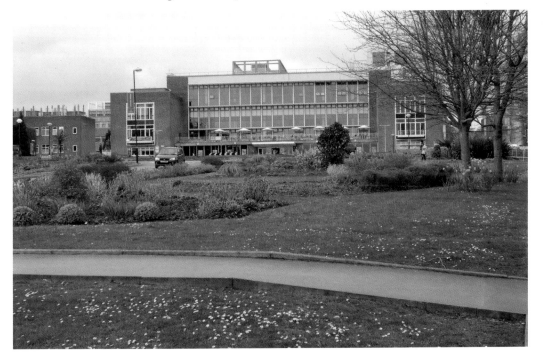

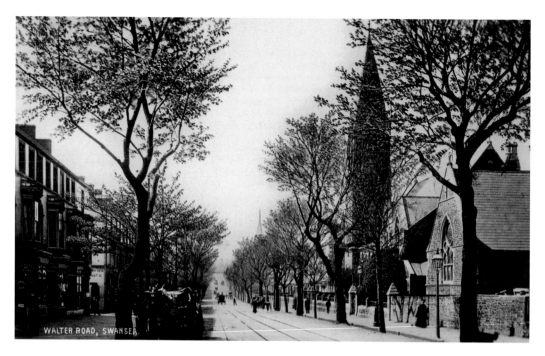

Walter's Road Looking West, 1908

Walter's Road is the main road leading west from the city centre towards Uplands, Sketty, Killay and Gower. Developed in the Victorian era, both sides of the road comprised mainly three- or four-storey terraced dwellings that were mostly occupied by families from the professional classes. There were two churches on Walter's Road, both of which have now disappeared. Here, the nearest church has become the Brunel Court block of flats.

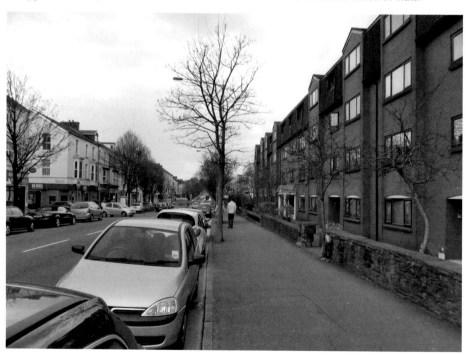

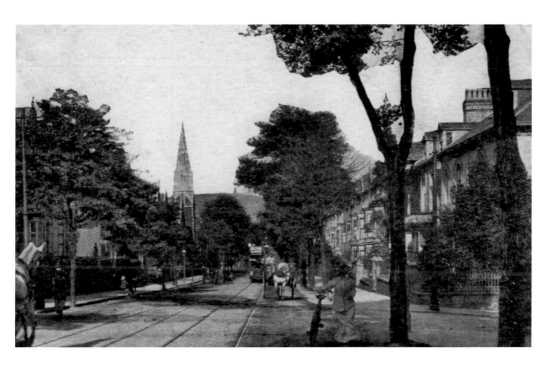

Walter's Road Looking East, 1906
In this view, the nearest church, the Memorial Baptist church, has been redeveloped as Ty Sivertson, a sheltered housing complex, with the church settled in new accommodation within the building.

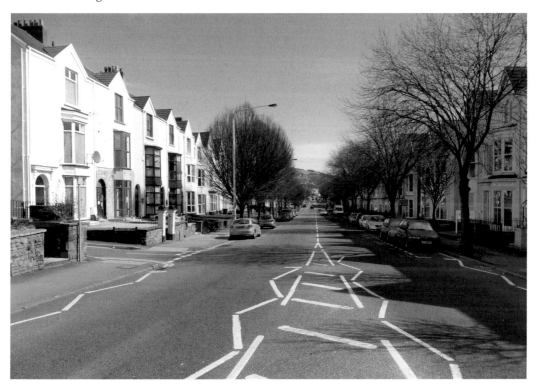

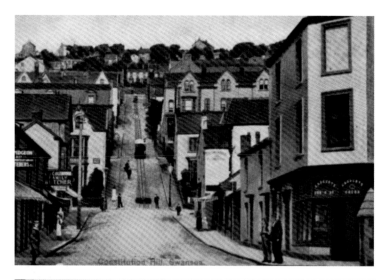

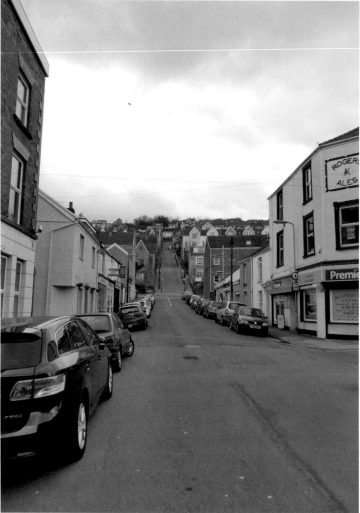

Constitution Hill, 1906
So-called because climbing it is good for one's constitution, this is a steep hill just off Walter's Road, which leads up to Terrace Road. In the early years of the twentieth century, a rack tramway provided a means of transport up and down the hill. This, however, fell into disuse and was not replaced. The hill has, however, remained largely cobbled, and driving down is something of an experience!

Swansea & District Private Nurses Co-operation & Private Hospital, 1916
Situated at No. 41 Walter's Road, this was a small private hospital with a long name. We can see that the matron up to 1916 was Mrs G. M. Edwards, who was succeeded by Miss B. H. Carter. Today, the building contains the offices of the Swansea Housing Association.

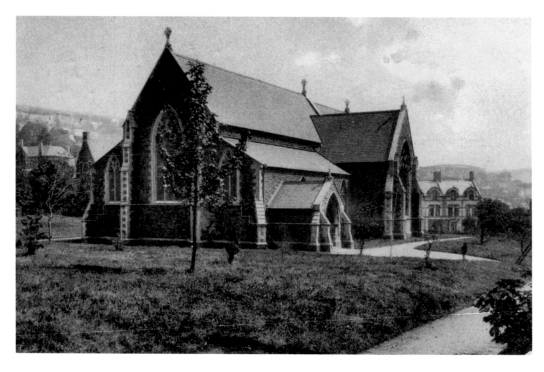

St James's Church, 1907

Situated at the end of Walter's Road, just before it reaches Uplands, St James's church was originally a chapel of ease to St Mary's church, having been built in 1867. During the Second World War, it became a temporary home for the congregation of St Mary's. In 1985, it became the mother church of its own parish. In the 1990s, sheltered housing was built around the church so creating a small community within the church grounds.

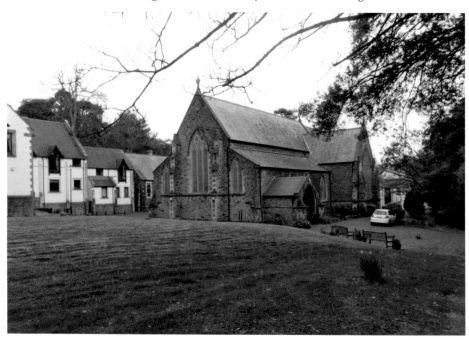

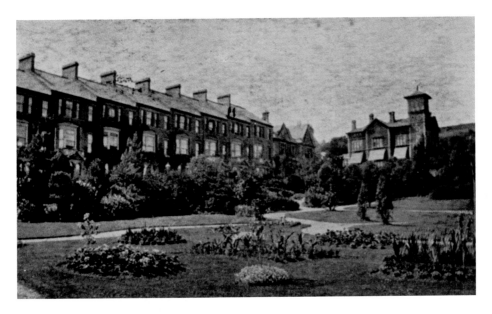

St James's Gardens, 1904
Situated behind St James's church, these gardens are quite secluded, and provide a small green oasis for local people. There has been little change over the last hundred or so years, apart from the trees becoming mature.

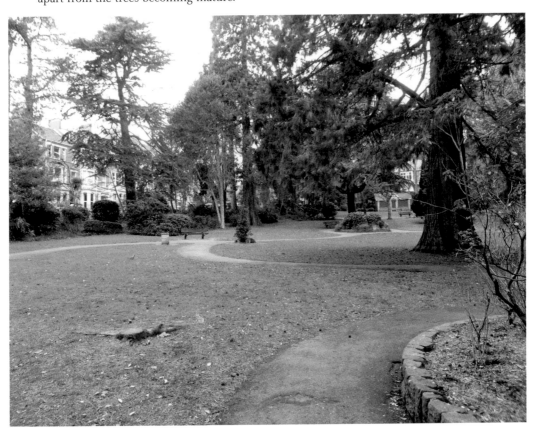

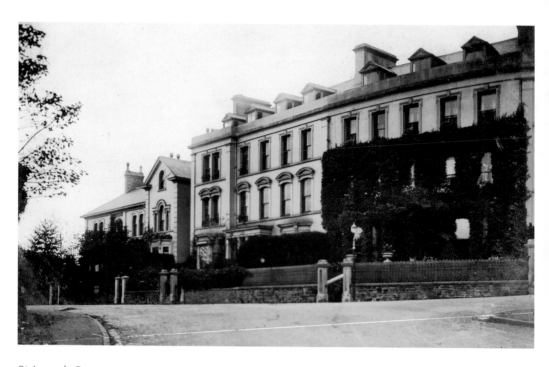

St James's Crescent, c. 1905

St James's Crescent curves around the grounds of the church, with some elegant Victorian town houses. A number of these have become offices.

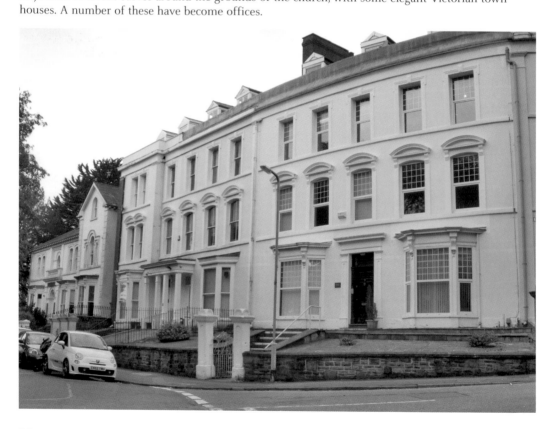

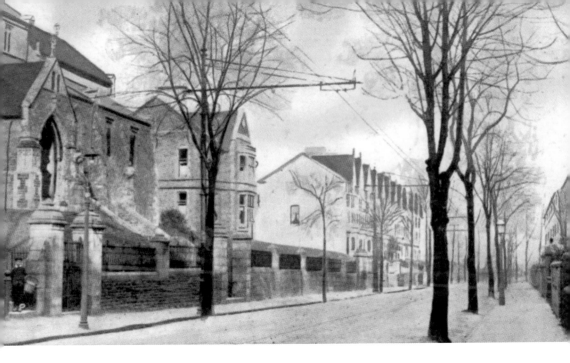

St Gabriel's Church, Bryn Road, 1907

Bryn Road is another long road that runs parallel with the Mumbles Road, separated from it by the Recreation Ground and St Helen's Cricket Ground. A popular residential street in Victorian and Edwardian times, it is now has a large amount of student accommodation, together with bed and breakfast establishments and small hotels. St Gabriel's church was consecrated in 1889, the bulk of the cost of building having been covered by Colonel William Llewellyn Morgan, intending it to be a memorial to his elder brother Jeffrey who had died in Ethiopia.

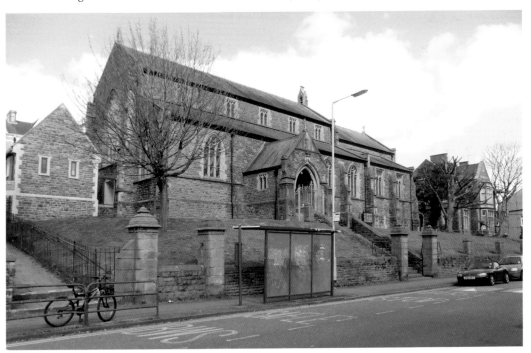

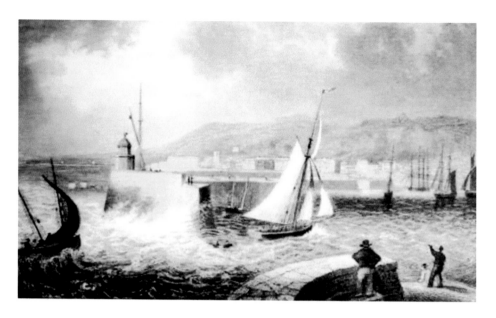

Entrance to Swansea Harbour, Eighteenth Century

The Swansea Harbour Trust was formed in 1791 to 'repair, enlarge and preserve the Harbour of Swansea'. Its first action was to widen and deepen the channel that formed the entrance to the Harbour. Today, the Port of Swansea comprises essentially the Kings Dock, with the Prince of Wales Dock at the heart of the SA1 development, and Queens Dock largely redundant. However, the growth of the leisure boating scene in Swansea and the success of the Marina at the old South Dock led to moves to make the River Tawe more boating friendly. The Swansea Barrage (or Tawe Barrage) was completed in 1992 and created a second marina at the mouth of the river. (*Above: The Alan Jones Collection*)

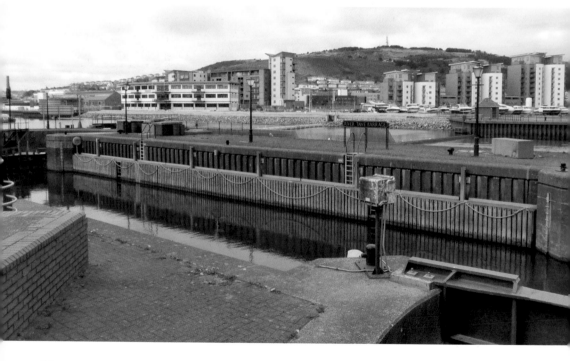

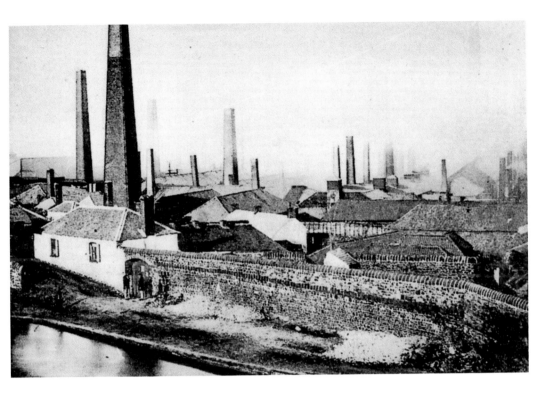

Hafod Copper and Silver Works, Early Nineteenth Century

The copperworks here opened in 1810, and for most of the nineteenth century were the largest copperworks in the world. By 1886, 1,000 people were employed on the site. Surprisingly, the works did not finally close until 1980, with the site becoming derelict. However, a partnership with Swansea University has led to work commencing on developing the site as an educational resource and visitor attraction. (*Above: The Alan Jones Collection*)

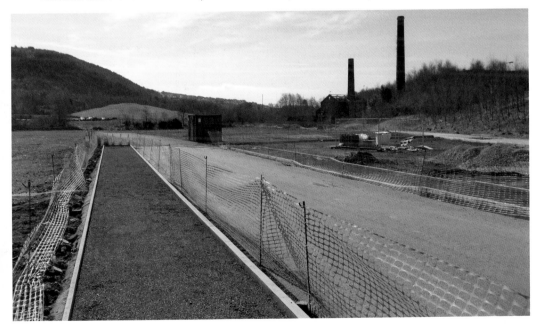

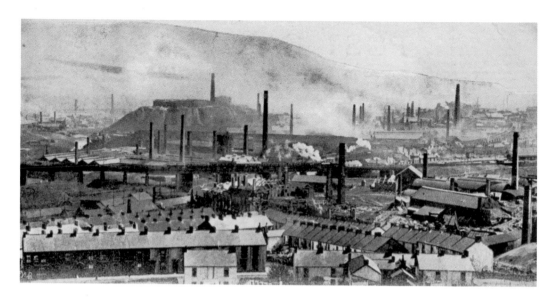

Landore, 1904

The Lower Swansea Valley was the crucible of the metallurgical industries that developed from the eighteenth century. As can be seen in this postcard view, the whole area was dominated by the chimneys of the many works. This was where the wealth was created that allowed the industrialists to build the opulent country houses to the west of Swansea. After the decline of these industries, the area was blighted by dereliction and tainted land. However, the Lower Swansea Valley Project revitalised the whole area, and here at Landore can be found the Morfa Retail Park, Liberty Stadium and Copper Quarter housing development.

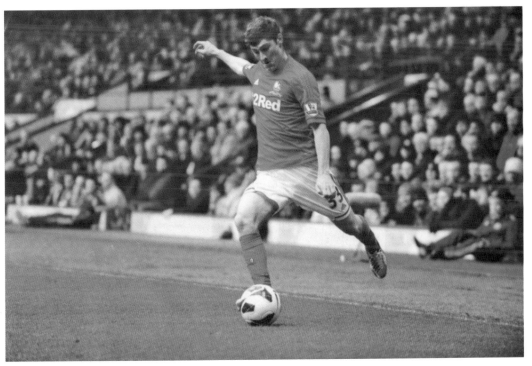

W. Ball of Swansea Town AFC 1913–14 and Ben Davies of Swansea City AFC, 2013
Swansea City AFC celebrates it centenary this year, 2013, and I thought it would be appropriate to end this book with the picture of W. Ball, who was a local lad who played for his new hometown club in its inaugural season. Appropriately, I have matched him with Ben Davies, also a local lad, who is now playing for his hometown team in the Premier League! Swansea City marked their centenary in style by winning the Capital One Cup.

Acknowledgements

The preparation of this book would not have been possible without the help of a number of people.

Firstly, I would like to thank the late Alan Jones, who accumulated a superb collection of images of Swansea, several of which appear in this book. I also must thank Peter Muxworthy for allowing me access to his wonderful collection, and allowing me to borrow freely. My thanks also go to Suzan Eames and Swansea City AFC for the photograph of Ben Davies, and to Mr D. K. Jones for permission to reproduce his photograph of Swansea's Victoria station.

I also have to express my gratitude to my family, especially my wife Alicia, who has proofread the text for me, and my son Steffan for his patience and assistance when out taking photographs. My special thanks, though, must go to my daughter Rebecca, without whose help, technical expertise and advice, none of this would have appeared in print.